Icons of Photography
The 19th Century

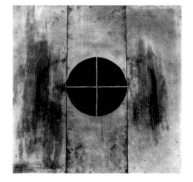

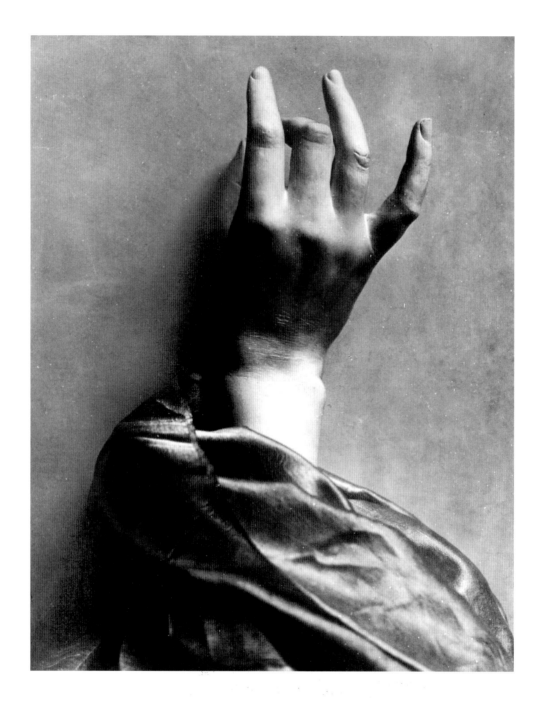

Icons of Photography
The 19th Century

**Edited and with an Introduction
by Freddy Langer**

Contributions by
Timm Starl,
Wilfried Wiegand,
and Freddy Langer

Prestel
Munich · Berlin · London · New York

Front cover Mayer & Pierson, *Comtesse de Castiglione* (see pp. 48/49)
Small photos on front cover (from top to bottom) Félix Nadar/Adrian Tournachon, *The Mime Debureau in Pierrot Costume* (see p. 46); Kuhn, *Locomotive after Crashing Through Wall of Gare Montparnasse, Paris* (see p. 108); Lewis Carroll, *Alexandra "Xie" Kitchen as "Tea Merchant"* (see p. 44); Robert MacPherson, *The Falls at Tivoli* (see p. 36); Robert Howlett, *Isambard Kingdom Brunel* (see p. 38)

Frontispiece Adolphe Bilordeaux, *Hand*, 1864

© Prestel Verlag, Munich · Berlin · London · New York 2002
© by the photographers, their heirs or assigns, with the exception of: Frederick H. Evans
by The Library of Congress, Washington; Heinrich Kühn by Diether Schönitzer, Birgitz,
Austria; Alfred Stieglitz by The Art Institute of Chicago (2002); Frank Meadow Sutcliffe
by The Sutcliffe Gallery – Whitby, by agreement with the Whitby Literary and Philosophical Society

Photographic Credits p. 128

Die Deutsche Bibliothek – CIP-Einheitsaufnahme data and the Library of Congress
Cataloguing-in-Publication data is available

Prestel Verlag · Königinstrasse 9 · 80539 Munich
Tel. +49 (89) 381709-0 · Fax +49 (89) 381709-35

4 Bloomsbury Place · London WC1A 2QA
Tel. +44 (020) 7323-5004 · Fax +44 (020) 7636-8004

175 Fifth Avenue, Suite 402 · New York, NY 10010
Tel. +1 (212) 995-2720 · Fax +1 (212) 995-2733
www.prestel.com

Translated from the German John W. Gabriel, Worpswede
Copyediting Deborah Fox-Heatley
Editorial Direction Christopher Wynne

Design and layout Cilly Klotz
Origination Repro Ludwig, Zell am See
Printing and Binding Sellier, Freising

Printed in Germany on acid-free paper
ISBN 3-7913-2771-2

Contents

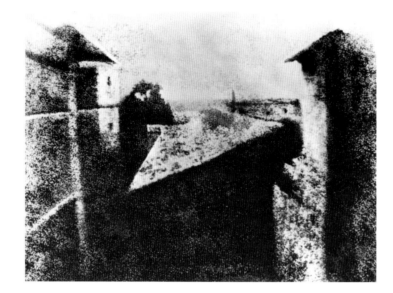

Joseph Nicéphore Niépce, View from the Photographer's Studio, 1827. The earliest known photograph ever taken.

Preface

At a period of endless bombardment with imagery one sometimes feels the understandable desire to close one's eyes, erase one's visual memory, and start all over again with a clear mind—to point a camera lens for the very first time at some motif and quite naively ask the world what it has to offer. Could it have been more than laziness that led the three inventors of photography—Niépce, Daguerre, and Talbot—to turn their cumbersome apparatus out a window during their first experiments, each independent of the other? Might there not have been something more at stake than testing a new technique, conducting an experiment that linked the formulae of physics with those of chemistry?

Photography was the first medium to truly open our eyes to the outside world, to show us its variety and beauty, and its injustices; in short, to reveal its secrets. The pioneers of photography prophesied early on that it would do just that. The only surprising thing was the rapidity with which the new technique spread and, after only a few developmental steps, was brought to perfection. It was simultaneously the miracle and the dilemma of photography that in far less than half a century after its invention, everything the camera was capable of doing had in fact been done, conventions—which are still valid today—had been established, and seemingly everything that could be brought in front of a lens had been captured on film. All the more astonishing that the early works in the medium were so long forgotten and the raison d'être of its masterful nineteenth-century accomplishments had to be justified in face of modern art, rather than vice versa.

On the other hand, hardly anyone would have been surprised if the introduction of the Kodak Box, the first amateur camera, in 1888, or its popular successor, the Brownie, at the turn of two eras in 1900, had prompted the cry: "From today on, photography is dead," just as the French painter Paul Delaroche, when viewing a daguerreotype, is said to have proclaimed the death of his own art sixty years previously. Yet no such gnashing of teeth apparently occurred. The end of expert camerawork was announced much more laconically by the American photographer Alvin Langdon Coburn, who quipped: "Now every nipper has a Brownie." Less than a hundred years later, with the triumph of digital imaging technology and infinitely combinable pixels, photography has begun to explore yet another stretch of *terra incognita*—perhaps digging the grave of classical photography in the process. At any rate, the contemporary debate has begun to revolve around the essence and authenticity of photography, while the question that was closest to the hearts of earlier generations—whether or not photography is art—has been answered with a unanimous and rather glib "yes."

Dealing with the topic of nineteenth-century photography implies reading the subtext of photography from today's point of view. A prime mark of these works is that they are still capable today of rousing the astonishment felt back then, by both their authors and their audience. This feeling results not only from sheer respect for the technical virtuosity required to make photographs at that period. It reflects a realization that what we see here is an entirely new visual world, created by a handful of visionaries. Of course they were not entirely free from the influence of patterns and traditions, and they occasionally oriented themselves to the mannerisms of painting.

Still, from the very beginning, photographers also sought continually new means of expression and representation of which only this technique was capable. For the photographic artist of the nineteenth century, virtually every new picture amounted almost automatically to an experiment, representing both image and interpretation simultaneously. And beyond this, in the most fortuitous cases, the result became a beacon for a new art.

Just under sixty such pioneering works have been brought together in the present book. They represent a kind of *musée imaginaire* of the early days of photography, a compilation of intentions and aims on a quest for their intrinsic aesthetic. They tell the history of photography as if in a stop-motion film. Yet these images are much more than that they represent the foundation of our collective visual memory.

In All Beginnings Lies an Inherent Delight

Freddy Langer

The dream of photography is perhaps just as old as the invention of the mirror. Wouldn't anyone who saw his or her own reflection in the soft glow of glass or metal feel the desire to capture it and carry it away as an image? To freeze the moment, to banish time, to overcome transience? Photography is first and foremost a medium of vanity. "Stop awhile, thou art so fair," whispers the photographer to the magic moment, and presses the shutter release.

If we can believe the English gentleman and scholar William Henry Fox Talbot, it was indeed dented pride that inspired his experiments with light-sensitive substances. During his honeymoon to Bellagio on Lake Como in the summer of 1833, he was dissatisfied with his drawings of the mountainous landscape. Despite such technical aids as *camera lucida* and *camera obscura,* they always turned out like childish scribbles. How wonderful it would be, he dreamed, if one could make these natural pictures impress themselves permanently on paper and remain there forevermore.

Back at his estate, Lacock Abbey near Bath, Fox Talbot turned his attention from aesthetic concerns to those of technique and chemistry. He began to investigate the effects of sunlight on silver nitrate and silver chloride, sodium thiosulfate and potassium iodide, gallous acid, acetic acid, and salt solutions, as well as the reactions of all these chemicals with one another. Artistic vision? No trace of it yet. In the course of his experiments he discovered the potential for reversal offered by the photographic negative in early 1835—the "photogenic and skiagraphic process," as he termed it. He was able to present his first picture in August of that year—the view from the window of his house. But Fox Talbot by no means dreamed of new horizons. Instead, he sat quietly bent over the postage stamp-sized sheet and wondered at the sharpness with which it reproduced the window's leaded panes. When the picture was made, he noted with punctilious fascination, "the squares of glass about two hundred in number could be counted, with the help of a lens."

Gratified with having solved this problem in physical chemistry after a year and half of research, yet before fully developing the answer, Fox Talbot filed away his results and turned to other tasks. He wrote a book called *Hermes, or Classical and Antiquarian Researches,* in an attempt to combine his knowledge of archeology and philology. Who knows whether Fox Talbot would ever have returned to photography had the news not reached him from France, in January 1839, that a certain Louis Jacques Mandé Daguerre had found a way to "capture the images that paint themselves inside a *camera obscura,* such that they are no longer passing reflections of objects but their stable and lasting impression?"

The news banished every thought of a quiet country retirement. Fox Talbot took it as a challenge. In the space of only three weeks he made sure his discovery was in a presentable state for the public and he demanded recognition as the inventor of the new technique.

Daguerre's pioneering achievement had been reported to the French Academy of Sciences by the French physicist and astronomer Dominique François Aragon on January 7, 1839. The rumors that had cropped up in the press were confirmed. An astute businessman, Daguerre had steadily leaked snippets of information about his new method. "His discovery looks like an incredible miracle," wrote the *Gazette de France* as early as January 6. "It flies in the face of all scientific theories concerning light and optics, and promises, should it prove true, to effect a true revolution in the painterly arts."

Fox Talbot was not the only one to rub his eyes when he read such words as "miracle" and "revolution." In Stone, Buckinghamshire, the clergyman Joseph Reade claimed in 1837 to have invented a photographic process. Another inventor of photography, the Norwegian lawyer and inventor Hans Thøger Winter, also made claims. Less sweeping claims were made by Antoine Hercules Florence, a French man living in the Brazilian city of São Paulo. Although he pointed out that he had made

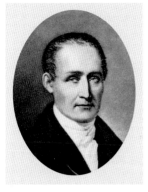

Nicéphore Niépce 1765–1833

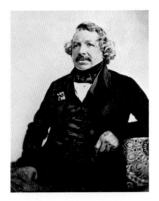

Louis Jacques Mandé Daguerre
1787–1851

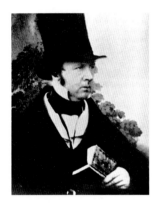

William Henry Fox Talbot
1800–1877

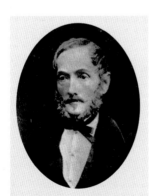

Hercules Florence 1804–1879

Hippolyte Bayard 1801–1887

photographs as early as 1832, Florence considered himself more of a footnote to history, since he had not continued his experiments. And in Paris, the finance official Hippolyte Bayard raised his voice. Using a method of his own, he said, he had succeeded in making direct positives, thirty of which he had presented in an exhibition in the summer of 1839.

To sum up then, the discovery of photography was up in the air. So advanced at that period were the necessary skills in chemistry and physics that a string of scientists immediately reacted to Aragon's announcement with their own photographic processes—some months before he finally revealed the principle on which Daguerre's technique was based. These early pioneers included the English astronomer John Herschel and the Germans Carl August von Steinheil and Franz von Kobell.

But one pioneer of the medium could no longer make himself heard: Nicéphore Niépce. He had died of a stroke in 1833. Seven years previously, in 1826, he had brushed a zinc plate with bitumen dust and exposed it for eight hours in the window of his study. The resulting image—Niépce called it a "heliograph," or sun picture—still survives. Although far from perfect, with a bit of goodwill one can make out the roofs and buildings of a farmyard in a meadow, near Chalon-sur-Saone in France. It is the earliest known surviving photograph.

Daguerre had discouraged Niépce from publishing his imperfect process. Instead, he suggested, they should improve and market it jointly. The partnership was ended by Niépce's sudden death. Daguerre continued the experiments on his own and found a satisfactory method of making permanent photographs using considerably shorter exposure times. Despite the accusation to the contrary, Daguerre by no means diminished Niépce's contribution to the invention when he published it. But he did give his own name to the process, "daguerreotype." On August 19, 1839, the technical, chemical process was explained before the French Academy of Sciences. By this time the French government had bypassed all the squabbling among the would-be

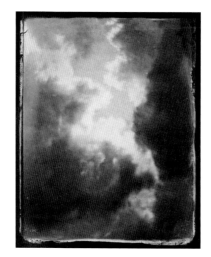

Carlo Baldassare Simelli, *Clouds*, c. 1860–65

inventors by acquiring the patent from Daguerre and Nicéphore Niépce's son in exchange for a pension. They wished to present it on that day "to humanity." Just weeks later, photographic studios began to open around the world.

Daguerre was not surprised by this unprecedented triumph. "What I make known to the public," he explained in a leaflet, "is one of the few discoveries that, both through their principles and results as well as through the favorable influence they may have on the arts, count among the most useful and extraordinary inventions." The daguerreotype not only fulfilled the ancient desire to fix one's own mirror image, its silvery, shimmering surface recalled a mirror. Perhaps it was this effect that so intrigued and charmed people. It must have seemed like something out of a fairytale, the way reality was reflected in the tiniest detail in these images. The more unprepossessing the subject, the greater was viewers' enthusiasm. They even began to marvel over bits of straw, apparently blown into a gutter by the wind, which they detected as delicate lines on the image. It was like seeing the world for the first time. And people rapidly realized how much of the world they would soon be able to see. "What an advantage for architects to take the whole colonnade of Baalbek, or the gewgaws in a Gothic church, in ten minutes in perspective on a picture," wrote Alexander von Humboldt in a letter of February 25, 1839, after Aragon had shown him a few daguerreotypes.

It was still the precision of reproduction that intrigued people most about photography. And if it truly prompted the artist Paul Delaroche to exclaim, "From today on, painting is dead!" as it is said to have done, he may well have had the exact reproduction of architecture and landscapes in mind, and possibly the popular art of portrait miniatures as well. Yet the proclamation also highlights the insight that the technical medium was

perhaps more than a mere chemical and mechanical process. Delaroche's pronouncement triggered a debate on the character of art and the content of photography, which continued to rouse passions on both sides. People seldom came down in favor of the mechanically produced image.

Art, according to the predominant view, could never emerge from a combination of reality and machine. Photography lacked possibilities for interpretation, the expression of a vision, or the reflection of personal sensations. Even Lady Elizabeth Eastlake, wife of Sir Charles Eastlake, who was not only president of the Royal Academy but first president of the Royal Photographic Society, denied photography a place in the fine arts. In an essay of over twenty pages, "Photography," published in the *London Quarterly Review* for April 1857, she stated that photography had another role: "For everything in which Art, so called, has hitherto been the means but not the end, photography is the allotted agent—for all that requires mere manual correctness, mere manual slavery, without any employment of artistic feeling, she is the proper and therefore perfect medium." The fact that a photograph surpassed even the most accurate verbal description led Lady Eastlake to the conclusion that photography was an entirely new medium, "a new form of communication" among people which would "fill the space between them" as no letter, message, or painting ever could.

The question on the meaning of photography, its character and potential applications, had already been addressed by Fox Talbot as early as 1844. In his book *The Pencil of Nature,* published in several installments and illustrated with a total of twenty-four original prints pasted onto the pages, he gave a detailed description of his invention. One of his concerns was to develop his negative-positive process, because Fox Talbot still considered himself the legitimate inventor of photography. He

had had his invention patented and had gone to court numerous times to sue for the royalties he believed were due to him.

At the same time, however, Fox Talbot's essay developed into a fundamental discussion. Many of his explanations were touchingly simple. For instance, he pointed out that it had no influence on exposure time whether one photographed a single or several persons, since the camera took all the figures at once, no matter how many there were. Or, commenting on a view over the rooftops of Paris, he explained that the camera was dispassionate, capturing a chimney pot or a chimney sweep with the same dispassion as the Apollo of Belvedere. On the other hand, many of Fox Talbot's ideas and descriptions proved that he was a

Henri Le Secq, *Nature Morte*
"Fantaisies/Clichés," c. 1852

daring visionary. He mentioned how simple it would be to make reproductions, considered the future role of photography in solving criminal cases, and even predicted infrared photography. Like Daguerre, Fox Talbot did not doubt for a moment that photography marked the onset of a new epoch.

In view of the success of the new medium, the real application of this invention lay in the air not only for specialists and

scholars. Evidently the public awaited it with bated breath too. Although Daguerre's images were one-off productions—taken directly on the light-sensitive layer of a prepared metal plate that was subsequently shut away like valuable jewelry in a small box—they were such a resounding success that photography had become a mass medium even in its infancy. This was despite the fact that it was not until Fox Talbot's negative process—what he termed reversed and re-reversed copies—that prints in practically unlimited numbers became possible.

Admittedly photography required manual skills and discipline. The photographic material had to be prepared immediately prior to exposure and developed and fixed immediately afterwards. Cameras were cumbersome boxes, and exposure times were long. Makers of portraits usually clamped their sitters in position to prevent them from moving during the exposure. Yet none of these factors could prevent the emergence—alongside lavish studios furnished like the reception rooms of Baroque palaces—of hundreds of tiny backyard studios in all the big cities of Europe. A small bank loan was all one needed to buy the necessary equipment, and the potential profits were phenomenal. As suddenly as photography appeared on the scene, just as rapidly it became a part of life. Most customers were undemanding, and their wishes could be fulfilled by the simplest methods.

It was a heady period, not nearly so dignified as the surviving pictures would lead one to think. The papers were full of caricatures depicting studio customers as the victims of unscrupulous swindlers. Countless anecdotes made the rounds about photographers who assured their clients that under- or overexposed prints would grow lighter or darker with time. To make things worse, people who recognized themselves in portraits might well have been looking at someone the photographer had previously shot—the stiff poses and frozen facial expression were always the same. Not to seem entirely at the mercy of the camera, sitters clung to books, globes, or miniature

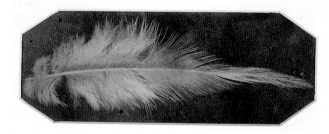

Greek columns—symbols of the things that would not necessarily be visible in their images, such as enlightenment, sophistication, and power. In the end though, these people tended to look merely worried or bored.

In the 1850s it was common practice to retouch faces on paper prints until they were unrecognizable in an attempt to adjust them to the current ideal of beauty. Before this practice, some photographers reputedly foisted portraits of someone else on their clients. Supposedly they did not notice the difference because they did not own a mirror!

Photographers themselves became victims of their profession when they inhaled mercury vapor in the darkroom. Nitroglycerin was produced when they mixed chemicals, resulting in several catastrophic explosions through the use of too much flash powder. In the 1860s the English press alone carried almost weekly reports of studio accidents.

The rapidity with which the various technical processes of photography supplanted each other back then seems almost incredible today. Direct images on copper, zinc, or glass; paper and glass negatives; wet processes and dry processes; paper covered with silver and salt, platinum, or a glaze of eggwhite; contact prints on large formats, and gimmicks like stereo photography, whose tiny formats simulated an amazing effect of depth when viewed through a device resembling spectacles. One method followed another in the first decades, each time making photography a bit simpler, until finally, in 1888, George Eastman Kodak put his Kodak box on the market and with it a camera in every amateur's hand. The millions of pictures that already existed soon burgeoned into the billions.

Our view of nineteenth-century photography is sometimes still shaped by its mass products—the portraits, wedding photographs, company celebrations, and views of towns and landscapes stacked in shoeboxes in today's flea markets. Landscape and urban shots were printed in photographic factories and bought by tourists as souvenirs, just as we buy postcards today. People collected them too by the hundreds in order to obtain a more complete picture of the world than that conveyed by newspapers and magazines. What we now call the print media were still illustrated back then with wood or steel engravings, since printers literally did not know how to obtain the glossy smooth surface of photographs.

Still, the photographs and photographers who served the needs of a mass audience were merely the primal ooze out of

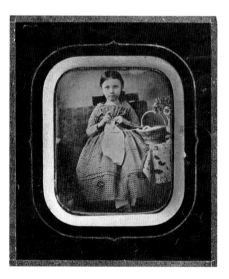

which emerged a handful of brilliant talents, women as well as men. "Photography is an enormous stride forward in the region of art," declared an author in the English *Photographic Journal* in 1857, taking an antithetical position to that of Lady Eastlake, cited above. Then he hazarded a prophecy that there

would be perhaps new Raphaels and Titians in the realm of photography, "founders of new empires, and not subverters of the old." Today we know that they had already emerged by the time this prophecy was made. For unlike the technology, which improved from year to year, the aesthetic potential of photography was explored and new changes rung in ever new variants.

The second generation of photographers already included great masters. Some were painters who found the new medium better suited to conveying their visual ideas; others were idlers who viewed photography as a path to self-development. Others had technical minds and arrived at a new aesthetic more by chance than by intent. And many were professional photographers who viewed every job as an artistic challenge, whether it involved portraying a private client or recording cathedrals for the department of national monuments. These photographers were not solely concerned with compiling

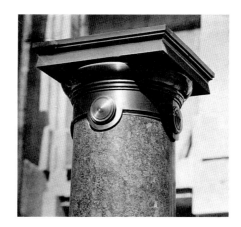

Delmaet & Durandelle, *Column, c.* 1868

a visual catalogue of the world, although they supplied a range of pictures from exotic lands to domestic households and they offered, on subscription, images of famous contemporaries to be collected in special albums. Suddenly, everything seemed accessible. But photographers' interest soon transcended pure reproduction or documentation. They began to translate visions, represent dreams, seek out and create scenes that reflected their temperaments and passions. Like no other medium before, photography succeeded in linking insights with sights of the visible world. During the process, the greatest among these early photographers created a universal language that still allowed them to shine individually. There was an early and astonishing realization that grew ever stronger as people's amazement at the new technology diminished. People realized that photography was, after all, not a mirror that dispassionately reflected reality. On the contrary, it was highly subjective.

Louis Jacques Mandé Daguerre

LOUIS JACQUES
MANDÉ DAGUERRE

1787–1851

worked as a theater director before
inventing the diorama, a presentation
employing transparencies, opening
in Paris in 1822. In 1826 he began a
collaboration with Joseph Nicéphore
Niépce, who had already succeeded
in producing photographic images but
had found no method to permanently
fix them. Daguerre discovered a
solution and sold his invention to the
French nation, which announced it to
the public on August 19, 1839.

Boulevard du Temple, Paris 1839

Boulevard du Temple was one of the busiest streets in Paris, a favorite haunt of itinerant players and musicians. On account of the thrillers and melodramas performed in several theaters there, it was also known as "Boulevard du crime." It lived up to its name when an assassination attempt was made there on the king of France in 1835. The reason Daguerre tested his invention at this spot was simply that his apartment provided this particular view down the street.

In spring 1839 he took three pictures, setting his camera up on different floors in the morning, at 12 p.m., and in the late afternoon. Apparently Daguerre wished to determine the influence of lighting conditions on image quality. Apart from noting their richness of detail, every commentator on these views has emphasized their unprecedented naturalistic depiction of human beings, such as the shoe shiner (whose upper body is not clearly recognizable because his work makes him move back and forth) and the customer standing next to him. The carriages and passersby, on the other hand, have, so to speak, moved out of the picture—an effect caused by the long exposure time.

Daguerre presented two of his plates to King Ludwig I of Bavaria, but due to improper handling, the images have since vanished from the surface (the present illustrations are based on earlier reproductions). The whereabouts of the third daguerreotype are unclear. The appearance of the boulevard, too, was altered during urban renewal measures begun in 1862. And since we now know that Daguerre succeeded in making a portrait of a man as early as 1837, the long-held assumption that *Boulevard du Temple* marked the first appearance of a human figure in photography has become yet another legend in the checkered history of the medium. T. S.

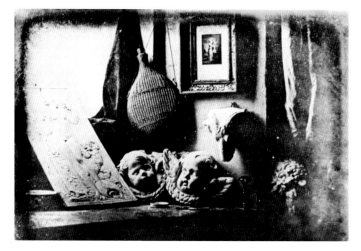

Louis Jacques
Mandé Daguerre,
*Still Life (Corner of
Daguerre's Studio)*, 1837

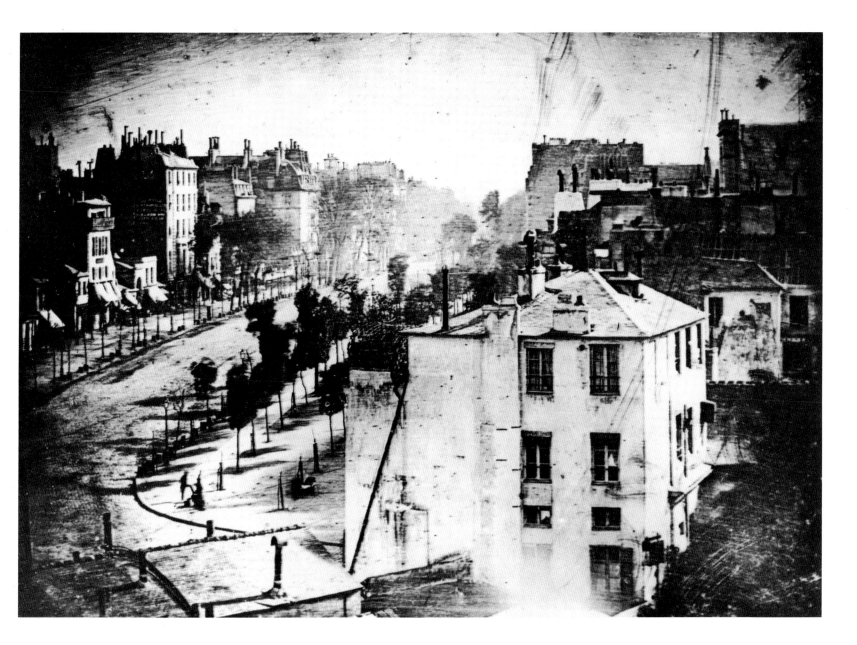

William Henry Fox Talbot

The Open Door April, 1844

Still life is a genre in which painting and photography come particularly close, because it excludes one of the determining elements of photography—chance, caused by movement and unknown to the other visual arts. The objects in front of the lens have been arranged or discovered by the author. Images of outdoor situations, in contrast, tend to be attributed to the attentive eye of the artist, implying an identification of the chance snapshot with a moment of insight.

William Henry Fox Talbot's photograph of an open door, illustrated in his publication *The Pencil of Nature*, creates the impression that he came across the rural scene just as it was. Actually he took several shots at different times of day, tried propping the broom against the left and right walls, tested the effect of hanging up a barn lamp, and altered the vantage point—yet this was merely playing with set pieces. His basic intention remained unchanged—to give the observer a look inward that was simultaneously a look outward. Our eye is drawn into the dark space and then out of it, through the barred window in the background. The charm of the image derives not only from the picturesque scene but from the encouragement it gives us, as viewers, to step into the picture and experience the reality of photography. This movement takes place in our imagination; the image is a true still life—while, at the same time, it is a study of the workings of perception. T. S.

WILLIAM HENRY FOX TALBOT
1800–1877

lived as a prosperous private scholar on his estate, Lacock Abbey, in England. In 1834 he conducted photographic experiments, which eventually led to the invention of the negative-positive process, which he called calotype. Talbot outlined the potential of the medium in numerous articles accompanied by sample compositions, thereby becoming the author of the first comprehensive theory of photography. He deserves to be considered the most significant figure among photography's many pioneers.

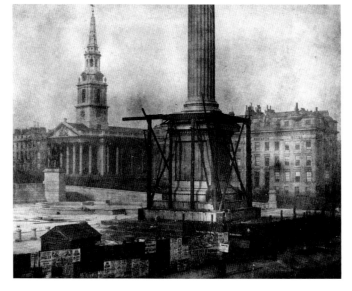

William Henry
Fox Talbot,
*Nelson's Column in
Trafalgar Square
under Construction,* 1843

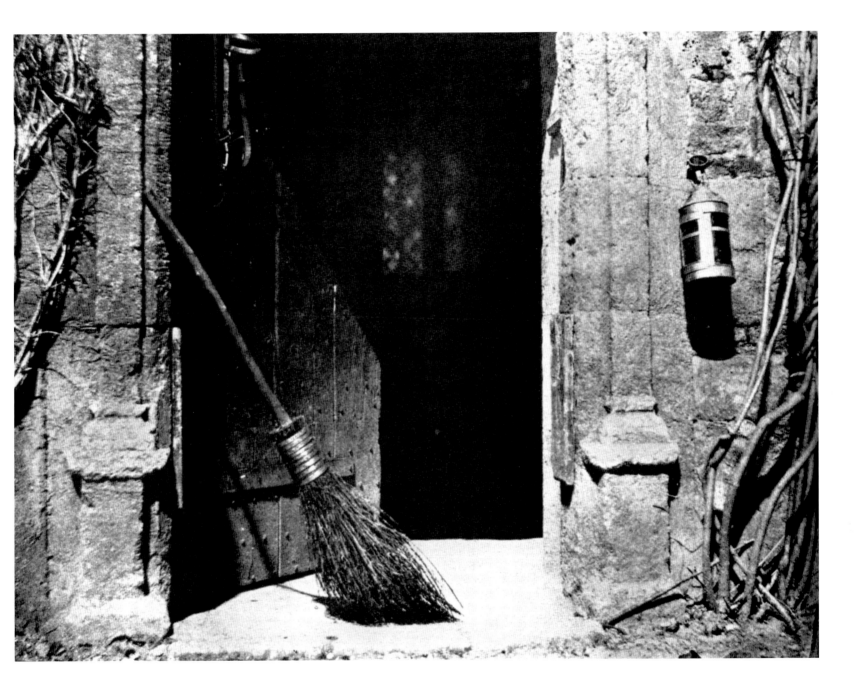

Hippolyte Bayard

Self-Portrait as a Drowned Man, Paris October, 1840

Even without the help of the title, it is obvious that the man pictured here is supposed to be dead, not merely asleep. The touching yet dignified pose, the carefully draped material, and the relieved, almost triumphant facial expression, all recall Christ's Descent from the Cross. Another model in painting was surely David's famous portrait of the eighteenth-century revolutionary Marat, assassinated in his bath, which itself contained an allusion to Christ.

In order to avoid blurring due to the long exposure time still necessary at that date, Bayard kept his eyes closed as he took this self-portrait. It was made by his sensational process of non-negative paper photography. Inscribed on the reverse of one of the three existing variations of the print are the words: "The corpse you see here is that of M. Bayard ... The government, which has done so much for M. Daguerre, has declared itself incapable of doing anything for M. Bayard, and the unfortunate fellow has thrown himself into the water out of despair." This carefully written text is signed "H. B." and dated "18 October 1840."

Was Bayard's staged image of himself after death an expression of true feeling or was it merely intended ironically to mislead the observer? Either interpretation is plausible and, as in the case of Cindy Sherman's role-playing today, both might ultimately be correct. W. W.

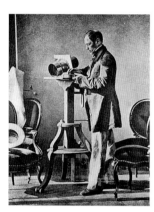

HIPPOLYTE BAYARD
1801–1887

was a finance official in Paris. He frequented artists' circles and emerged as one of the inventors of photography. He mastered every process of the day, and in 1839, invented the "direct positive" process on paper. His garden scenes and architectural prints show his brilliant sense for the best photographic vantage points.

Hippolyte Bayard,
*Colonnade at the Madeleine,
Paris,* 1846–48

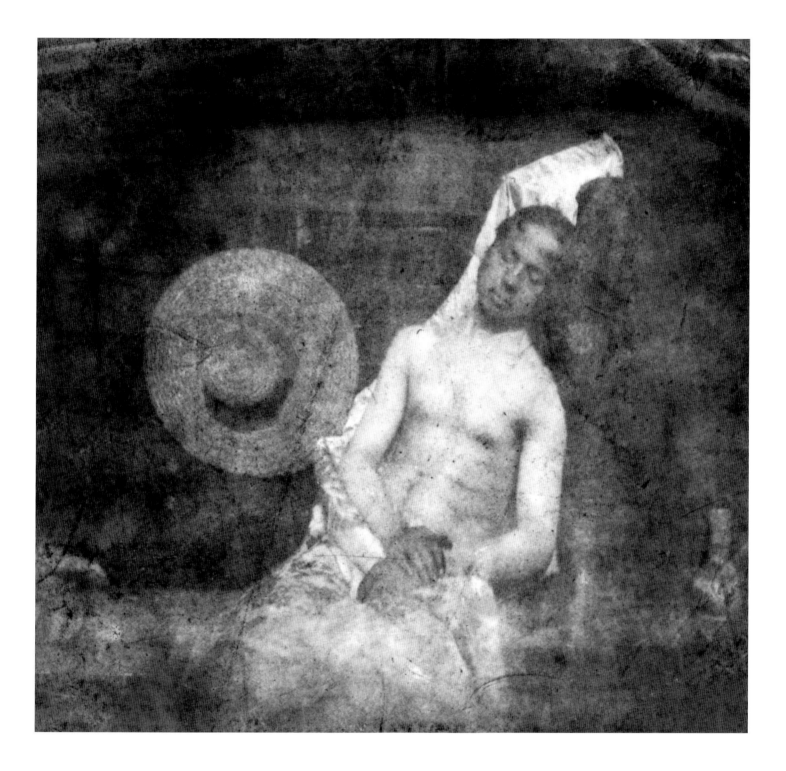

David Octavius Hill

Miss Mary McCandlish 1843

A young girl in her Sunday best is sitting in front of a patch of light on a wall, close to a climbing rose. Judging by her straw hat and and off-the-shoudler dress, it is summer. As she absentmindedly picks at a flower, her eyes stray into the distance. There is a mixture of mistrust, curiosity, and coquettishness in her gaze—an ambivalence that makes this portrait so charming. It is a perfect expression of the perennial problem of adolescence—indecision.

Hill found his model among the upper-middle class of Edinburgh. He generally posed his models outdoors, where sunlight permitted short exposure times. When taking portraits of artists, poets, scholars, and inventors, he took props into the garden and constructed mock interiors. Hill employed the calotype process developed by Fox Talbot (see p. 16) and skillfully took advantage of the soft-focus effects of the paper negative to create a wonderful play of halftones—a *chiaroscuro* inspired by Rembrandt, his great idol. W. W.

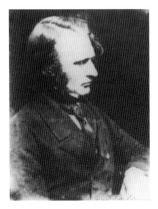

DAVID OCTAVIUS HILL

1802 – 1870

was a landscape painter in Edinburgh, Scotland. In 1843 he accepted a commission to paint a picture of the first assembly for the foundation of the Free Church of Scotland, including all four hundred and seventy-four members. To assist him, he hired the young photographer Robert Adamson (1821–48). Hill and Adamson also photographed respected citizens, humble fishermen, buildings, and landscapes, producing a total of about two thousand five hundred pictures in four years. Although soon forgotten, these images were rediscovered around the turn of the century to great acclaim. Hill's later photographs were less interesting and, like his painting of the assembly that he eventually completed in 1866—that had led him to photography in the first place—they too have been largely forgotten.

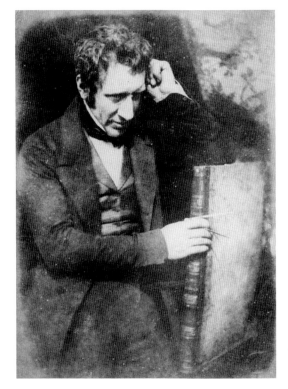

David Octavius Hill,
*James Nasmyth, Engineer
and Inventor,* Edinburgh,
c. 1844

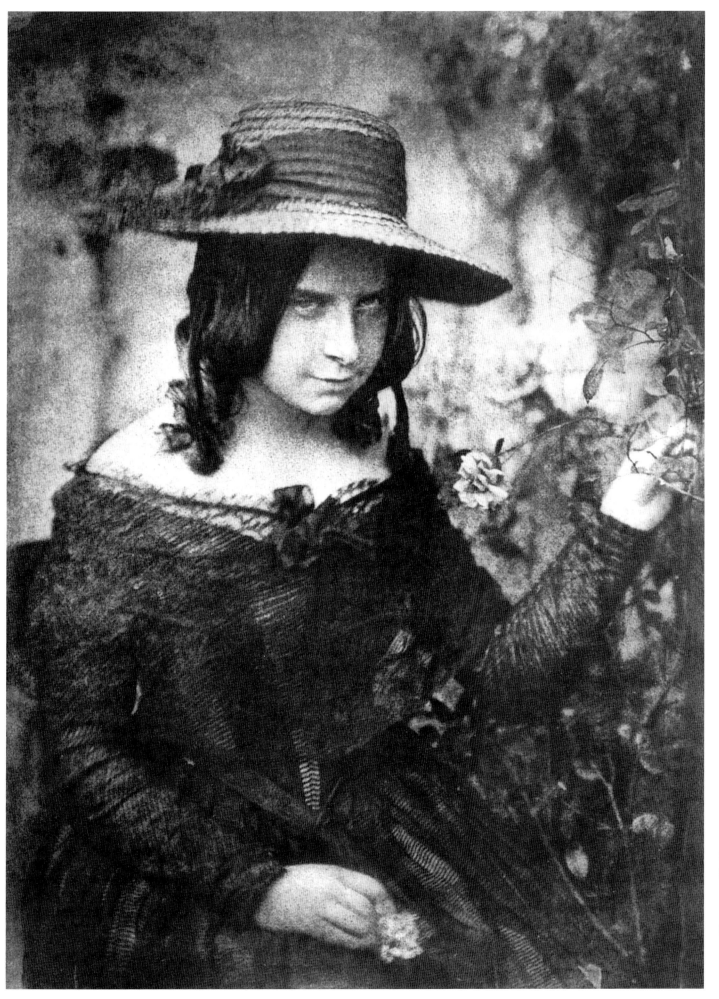

George N. Barnard

Burning Mills July, 1853

GEORGE N. BARNARD

1819–1902

opened his first photographic studio in Oswego, New York, in 1846. A number of others followed during his career, including studios in Syracuse, Charleston, and Chicago. Around 1860 Barnard traveled for Edward Anthony, a distributor of stereo photographs, taking pictures in Cuba and at the Niagara Falls. His photographs of the aftermath of the Civil War widened his reputation. Yet they remained the exception in a life's work that consisted primarily of commissioned portrait photographs.

Not long after the introduction of the daguerreotype, it seemed that everything that could be photographed already had been photographed. Only when it came to capturing motion was the new technique inadequate, since its exposure times were too long. This must have made George N. Barnard's picture of grain mills on fire seem all the more dramatic. Taken in Oswego, New York, on July 5, 1853, this image of a disaster as it was happening—possibly the first news photograph in history—anticipated the results. This was new. With the cumbersome equipment, photographers could do little more than record the consequences of such events. Ironically, Barnard's major work also reflected the limitations of the technique.

Barnard was initially one of a team of over twenty photographers with Mathew Brady (see p. 64) who were entrusted with documenting the Civil War. In 1864 he became official war photographer for General Sherman and accompanied him on his campaign from Tennessee to Georgia and South Carolina, culminating in the legendary "March to the Sea." Barnard generally photographed the results of Sherman's scorched-earth policy after the battles were over. Many of his photographs

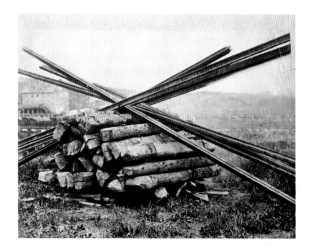

George N. Barnard, *Sherman's Hairpins*, 1864

show ruins of houses and devastated towns from a certain distance, which lends the images a sense of detachment. Yet some of his motifs are movingly symbolic of war, such as piles of railroad tracks and ties, or cannon balls and skulls that the photographer himself positioned carefully within the landscape. Sixty-one of these prints were published in 1866 in a collection called *Photographic Views of Sherman's Campaign.* It made Barnard famous.

In the fall of 1871 he was confronted one last time with a catastrophe, the Great Fire in Chicago, where he had opened a studio just five months previously. As he photographed the conflagration, this time with a stereo camera, Barnard's house and entire archive were consumed by the flames. F. L.

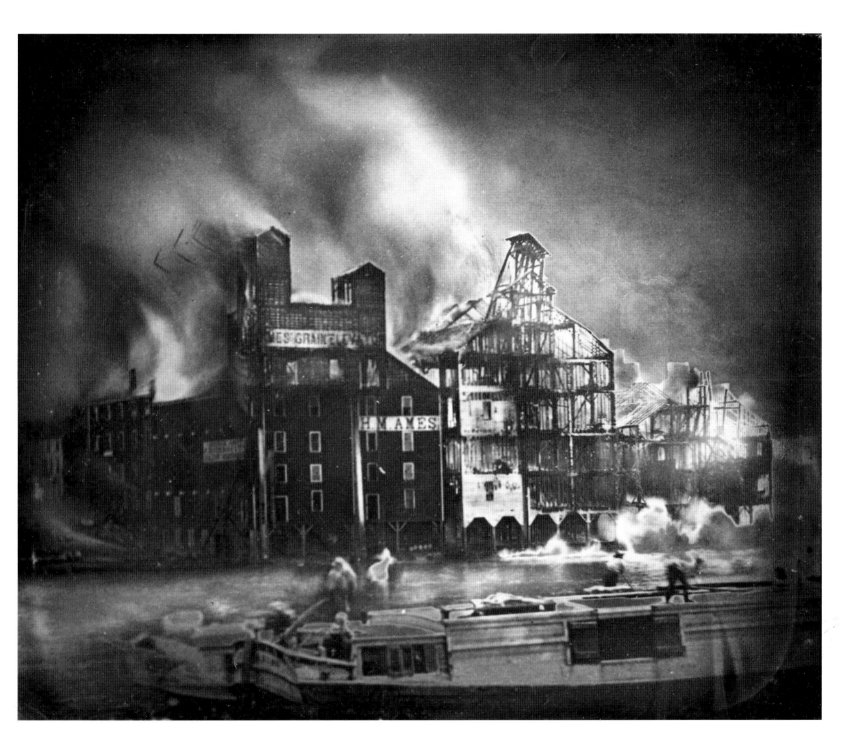

Alois Löcherer

The Torso Section of Bavaria, Munich *c.* 1848

ALOIS LÖCHERER

1815–1862

studied chemistry, worked in a pharmacy, and, in 1849, became a professional photographer. He made paper photography more popular than the daguerreotype process in Munich and became the city's leading photographer. He was renowned for his portraits and reproductions of art. By about the middle of the 1850s, Franz Hanfstaengl (see p. 52) and Löcherer's pupil, Joseph Albert, were regarded as Munich's most accomplished photographers.

At over fifty-two feet high, the statue of *Bavaria* in Munich was the largest bronze monument of its day. No surviving statue from Ancient Greece or Rome could compete. King Ludwig I of Bavaria was so proud of it that he exclaimed: "Nero and I are the only ones who have made something so grand." The statue was intended to honor great Bavarians and, at the same time, to celebrate Germanic virtues. Although the figure's head was obviously modeled on that of the Greek goddess Athena, her bearskin and oak wreath were Germanic attributes. It took thirteen years to finish the statue. Neither its sculptor, Ludwig von Schwanthaler, nor the King was to experience the unveiling on October 9, 1850.

The head of the six-part figure was cast first, in September 1844, followed by the torso in October 1845. Of the photographs Alois Löcherer made in front of the foundry between 1848 and 1850, five show the head and two the torso. This sequence of pictures represented one of the earliest ever photoreportages, although its appeal today probably lies more in its surrealistic effects than in the celebration of a once world-famous monument.

W. W.

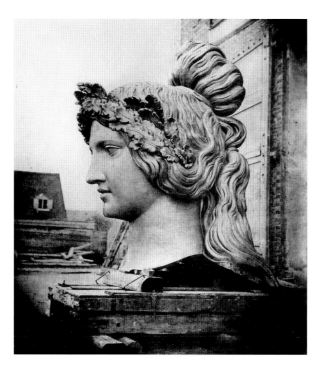

24

Alois Löcherer,
The Casting of Bavaria, 1850

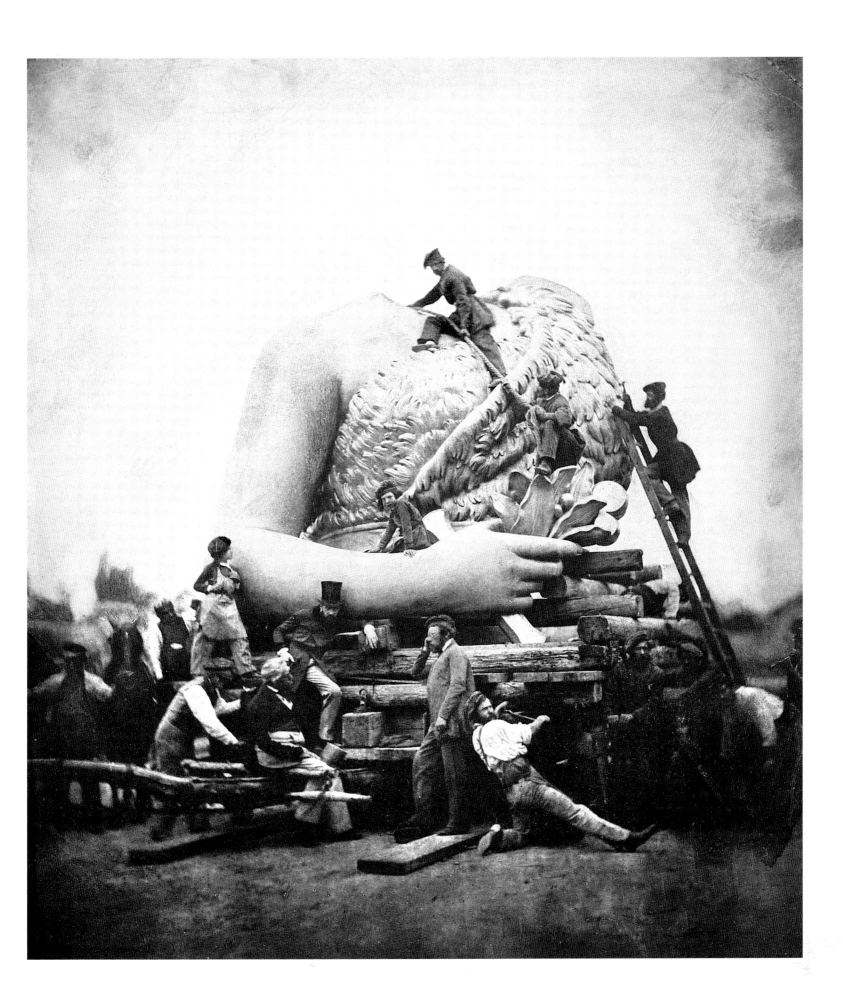

Charles Nègre

Le Stryge 1853

The radical critique to which Friedrich Nietzsche subjected the nineteenth century is more familiar to us today than the naive pride with which most people of the period viewed their era. Although we can understand that they were bedazzled by progress in science and technology, it is difficult to grasp their enthusiasm for buildings that imitated the styles of past periods. We tend to forget the extent to which the nineteenth century was a century of archeology, and that people thought they were experiencing a second Renaissance. Just as the first Renaissance had rediscovered Greco-Roman antiquity, the second, they believed, had breathed new life into the Middle Ages and all that followed. Poets and writers had enthused over Gothic cathedrals before art historians and curators. The most successful work to celebrate Gothic architecture was Victor Hugo's novel, *Notre-Dame de Paris 1482*, which, as *The Hunchback of Notre-Dame*, is still popular today.

Charles Nègre's photograph *Le Stryge,* which was distributed in countless reproductions, seems like a variation on several of Hugo's themes. The title means "The Vampire," and refers to the stone gargoyle, a highly imaginative reinterpretation of the medieval style. The dapper gentleman next to it is the photographer Henri Le Secq, a friend of Nègre's. While the gargoyle appears to gaze skeptically over the city, which stood on the verge of transformation due to the construction of Haussmann's boulevards, the photographer's commanding pose embodies all the period's pride in the Gothic Revival. W. W.

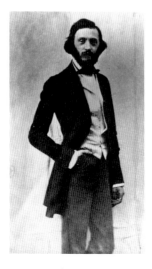

CHARLES NÈGRE
1820–1880

was born in Grasse in southern France, and studied painting with the then-famous Parisian history painter Paul Delaroche. For a time Nègre enjoyed just as much success as an artist as he did as a photographer, yet his technical curiosity drew him to the camera. He invented a method of reproducing photographs, made pictures of nudes illuminated in soft, painterly light, and produced unusually striking reportage photographs of street boys in Paris. He became particularly well-known for his superbly composed architectural views of the city and of areas in southern France.

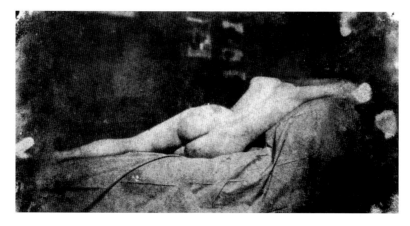

Charles Nègre, *Nude Viewed from the Back, c.* 1848

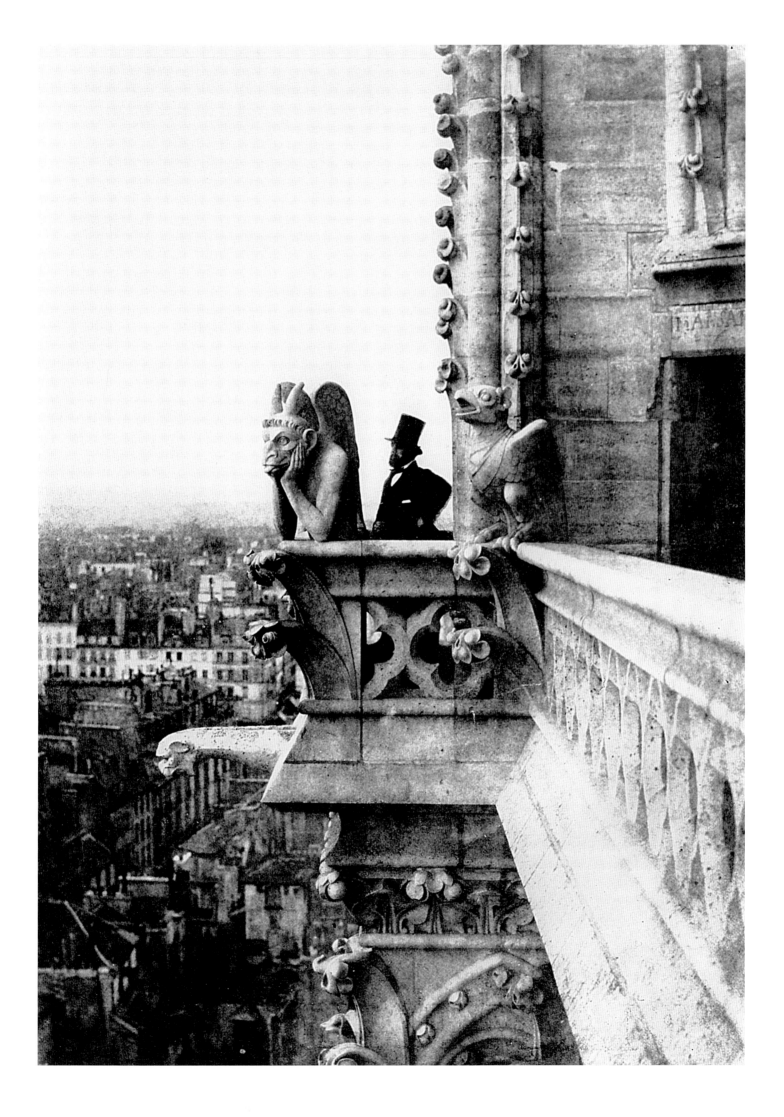

Maxime Du Camp

Statue of Ramses II in Abu Simbel 1850

MAXIME DU CAMP
▪ 1822–1894

from Paris, was a successful author of
travel books. From 1849 to 1851 he
accompanied Gustave Flaubert on a
Mediterranean journey that included a
long stay in Egypt, as part of a commis-
sion on behalf of one of the Ministries
in Paris. As preparation, Du Camp was
taught photography by Gustave Le
Gray. Du Camp took over two hundred
travel photographs, of which one
hundred and twenty-five were included
as original prints in a book published in
1852 together with an explanatory text.
Although the book of photographs was
highly praised, Du Camp abandoned
photography afterwards.

The treasures of Ancient Egypt exerted an irresistible fascination on nineteenth-century photog-
raphers. Although the brilliant sunlight made short exposure times possible, it was tiring carrying
cumbersome cameras through the heat and chemically processing negatives on site—a process that
remained necessary for decades. So every successful photograph from Egypt was considered a
triumph, as Maxime Du Camp's superb pictures of the temple at Abu Simbel exemplify.

The present image is composed like a souvenir snapshot. The photographer did not include
himself in the picture, as we tend to do today; he asked an Arab servant to play the part. It was less
important for Du Camp to prove that he had seen the sight than to demonstrate the scale of the
colossal statue. The use of people to give an idea of scale had long been common in painting and
printmaking, and photographers rapidly adopted the practice. It was not until the twentieth century
that photographs without any reference to scale became increasingly dominant in the context of
archaeology and art history. The scholar's and tourist's viewpoints have diverged. It is part of the
charm of early photography that this distinction was not yet made.

Topographical photographs of the period record a state that has long since ceased to exist.
Not only were the colossal statues of Abu Simbel removed to another site for the construction of
the Aswan Dam but the large scale tourist graffiti and the sand around the seemingly only half-
heartedly excavated monuments have vanished into the past like the century of which they were
a part. W. W.

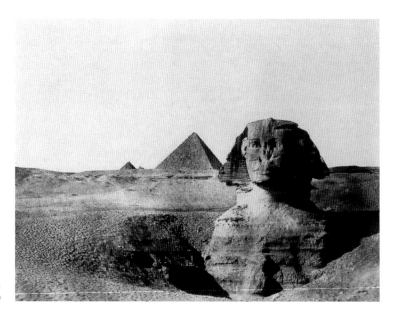

Maxime du Camp,
Sphinx, Giza, December 9, 1849

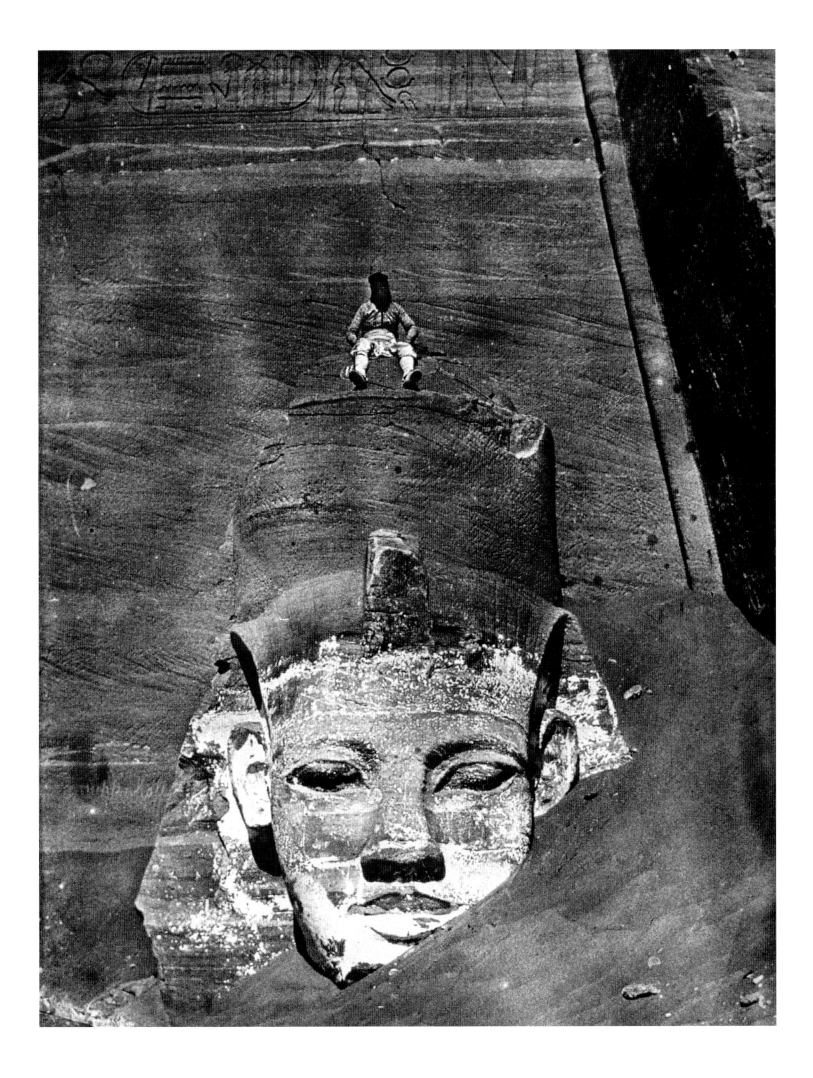

Francis Frith

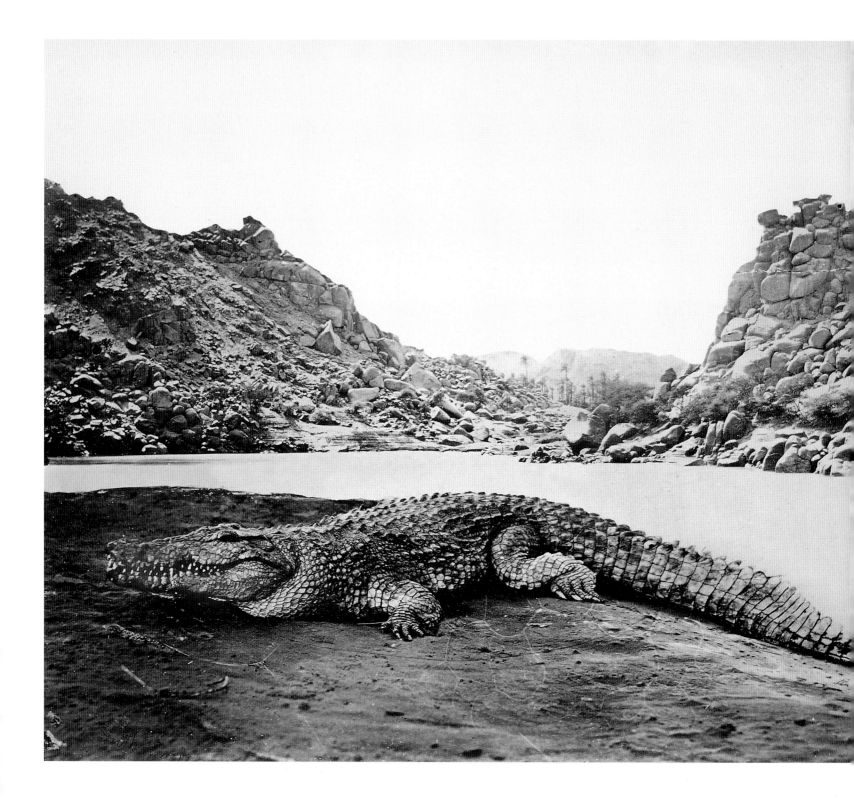

Crocodile on a Bank of the Nile 1857

It would be hard to imagine a greater enthusiasm than Francis Frith's when he declared that his first view of the pyramids marked a new era in his life. He had gone to Egypt in September 1856 to take photographs there, and subsequently took two further journeys to the Middle East. He brought back hundreds of pictures to England and published them in lavishly produced albums. Frith's images gave new impetus to the European craze for all things Egyptian that had come in the wake of Napoleon's first campaign in Egypt in 1798.

His pictures of pyramids, the Sphinx, temples, monuments, ruins, and sculptures, which took him up to the fifth cataract of the Nile, have shaped our visual conceptions of many of these historical sites to this day. The routes Frith took became models for classical study tours. Everyday life, however, interested him less. If, sometimes, he positioned an Egyptian against a towering wall, it was merely to provide a sense of scale. His pictures lack life. "The call of a romantic and perfect past" was "vastly more interesting than the unnatural and hectic present," was how Frith explained his choice of motif. His picture of a crocodile basking on a sandbank — apart from reflecting a fascination with the primeval lizard—contains a symbolic statement regarding the dark, dangerous, and disquieting side of African life. F. L.

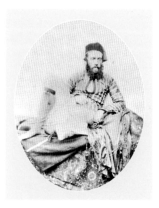

FRANCIS FRITH
1822–1898

was a businessman in Liverpool, England, who did not begin to photograph until the 1850s. Thanks to the financial success of his photographs of the Middle East, especially *Egypt and Palestine Photographed and Described,* published in an edition of 2000, he was able to establish his own company. Initially Frith set out to document all the towns and cities in Great Britain, but his business soon grew into one of the period's largest providers of photographs and postcards. His photographers toured the world. The company was still trading until 1968.

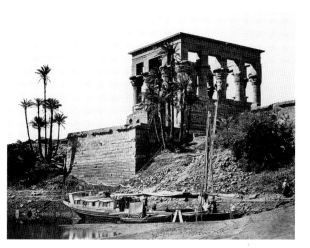

Francis Frith,
Temple on the Island of Philae,
1857

Philip Henry Delamotte

The Nave from the Great Gallery in Crystal Palace, Sydenham 1856

PHILIP HENRY DELAMOTTE
■ 1820–1889

son of a landscape painter and lithogra-
pher, taught drawing and perspective
at King's College, London, from 1856
to 1887. His involvement with photog-
raphy began in the late 1840s. After
initially working with calotype and wax
paper, he turned to the collodion emul-
sion process. His major achievement
was the photographic documentation
of the Crystal Palace and its relocation
after the World Fair. The pictures were
published in an album in 1855, as
was Delamotte's book *The Practice of
Photography, a Manual for Students
and Amateurs.*

The nineteenth century had a marked tendency to hold exhibitions. New markets had to be opened for the products of the Industrial Revolution, and this required a showcase. The most resplendent of these were the World Fairs, which offered both manufacturers and nations an opportunity to present themselves as vehicles and guarantors of progress. The first World Fair took place in London in 1851, where a building was erected specially for the purpose in Hyde Park. It was a magnificent structure of iron and glass, designed by John Paxton. The Crystal Palace was 1847 feet long, 407 feet wide and 108 feet high, housed about fifteen thousand exhibitors, and between May and October 1851, it attracted over six million visitors.

Photography, too, had the capability of shedding a flattering light on the achievements of the period, whether they were in the field of art or technology, business or science. What the camera captured found an audience not only in the context of such events but after they were over. Thus the young medium was represented in two different senses at the "Exhibition of the Works of Industries of All Nations." Cameras and prints were exhibited to illustrate the potential of the new process of imagemaking, and photographers recorded the extraordinary construction and interior of the Crystal Palace, its stalls and product lines. Their photographs served to publicize both the event itself and the participating manufacturers and their goods. T. S.

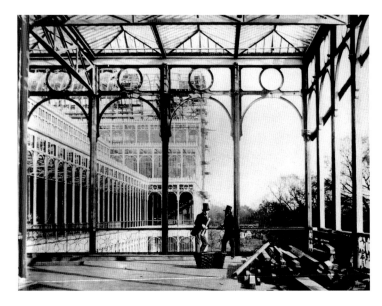

Philip Henry Delamotte,
The Crystal Palace, London,
1853

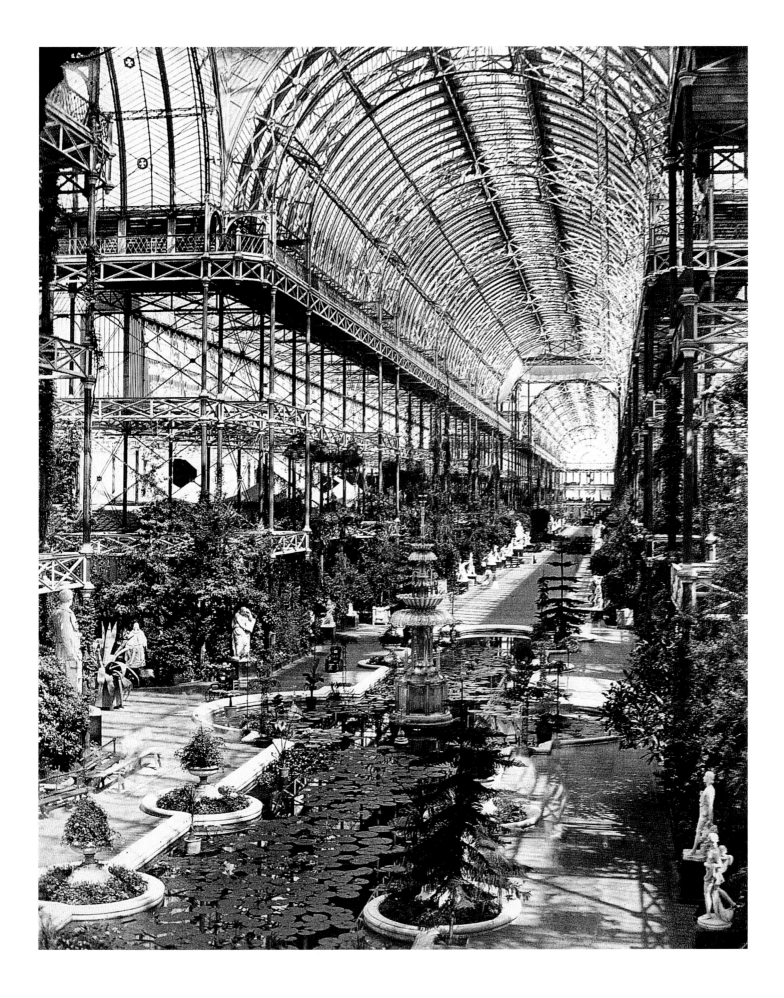

Gustave Le Gray

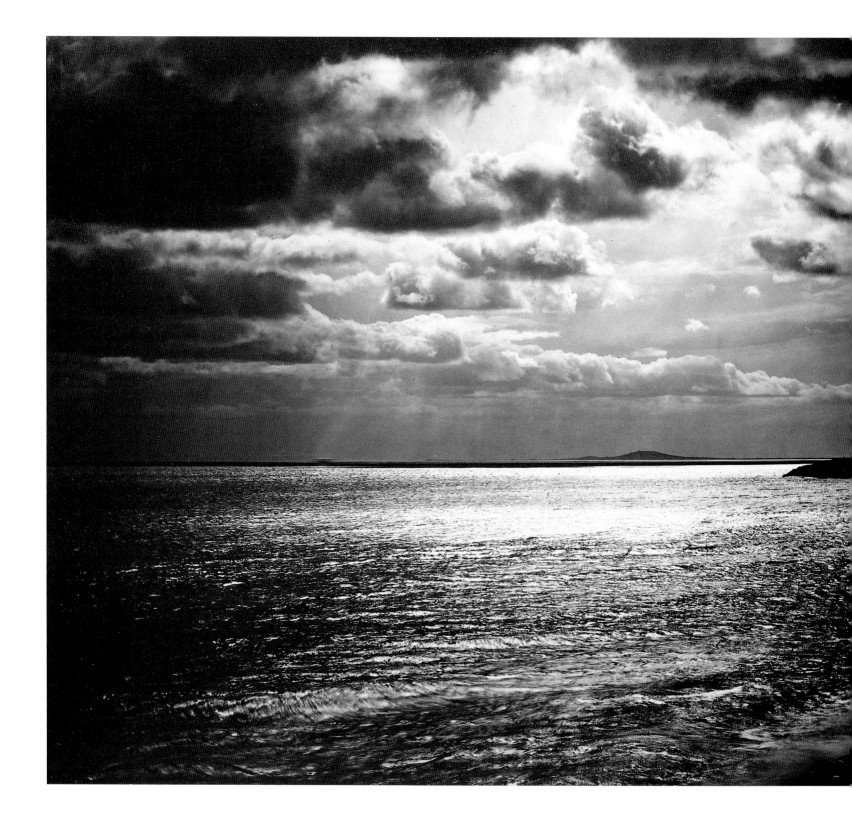

The Mediterranean with Mont Agde 1857

Gustave Le Gray's marine photographs must be counted among the masterpieces of the nineteenth century. He created a total of over forty photographs of harbors, beaches, and seascapes. Occasionally a breakwater defies the surf, or a lighthouse soars into the picture. In other images great sailing ships leave the harbor, or a tiny steamer chugs by on the horizon. In another photograph, white puffs of smoke from a warship's guns evoke a silent salute. Yet Le Gray frequently showed only the empty sea, rendered dramatic by an expanse of sky filled with towering clouds. He was especially partial to the effects of moonlight, with rays of light falling through a gap in the night clouds and reflecting on the waves.

Le Gray's photographs were, in fact, taken during the day. For the cloudy skies, he directed the camera toward the sun for long exposures, while using short shutter speeds to capture the agitated waves. At that time it was technically nearly impossible to record such diverse effects simultaneously.

It would seem then that two negatives were combined to produce a single print, and other tricks could have been employed too. The longer we look at such a photograph, the more we doubt whether its upper and lower sections really reflect the same time of day, and the same wind and lighting conditions. It is no coincidence that the horizon, the borderline between two negatives, is so razor sharp—Le Gray's magical hyperrealism anticipated the modern technique of photomontage. W. W.

GUSTAVE LE GRAY
1820–1884

studied painting in Paris. From 1843 he lived mostly in Italy, married a woman from Rome, and returned to Paris with her in 1847. He tried to make a career in painting but was more successful as a photographer. He made important technical inventions, and was highly valued as a teacher of photography. Despite several government commissions, he ran up huge debts and abandoned his impoverished family to go to Egypt, with a detour in Sicily. After arriving in Egypt in the winter of 1861, he eventually became a drawing teacher. He continued to participate in photographic exhibitions in Europe. Le Gray died in Cairo in 1884.

Gustave Le Gray,
The French Crimean Fleet Returning to Toulon with the Body of Admiral Bruat,
December 2/3, 1855

Robert MacPherson

Robert MacPherson, *View over Rome from the French Academy, Monte Pincio, c. 1863*

ROBERT MacPHERSON
■ 1811–1872

was born in Edinburgh, where he later studied medicine for four years before settling in Rome. Initially he worked as a landscape painter and became a very successful art dealer. It was not until the early 1850s that he was taught how to use a camera by a medical colleague. Soon his unusually composed and cropped views had brought him greater popularity than his closest rival, James Anderson (1813–77), who had established himself in Rome some time before. MacPherson made numerous experiments with photomechanical reproduction processes, and today is considered the aesthetically most outstanding photographer active in Italy in the nineteenth century.

By the time the Seven Years' War came to an end in 1763, England had become the most powerful colonial empire in the world. Their new self-confidence seems to have encouraged the British to conquer the Continent again, this time by peaceful means. The Grand Tour, a study trip to the classical sites of ancient Greece and Rome, became all the rage among young English noblemen, and was soon taken up by the middle class. This swarm of travelers resulted in a growing demand for city views, architectural pictures, and art reproductions. Only a few years after its invention, the modern medium of photography became a serious rival to the traditional engraving technique.

Not surprisingly, British photographers began to settle in Rome. The most famous was Robert MacPherson, a Scotsman whose views of the city and its environs exhibited an unusual aesthetic sensibility. Unlike most photographers of Italian motifs, MacPherson had a penchant for asymmetry and occasionally even included unattractive natural features in his compositions. He was the only photographer in this field to have an extensive range of expressive possibilities at his fingertips. He could be as soberly realistic as the most advanced landscape painters of the day, and the next minute aim for a carefully balanced pictorial harmony.

MacPherson's pictures were just as far removed from the prettiness of today's postcard motifs as from the Roman views of the famous painters and printmakers of the period. They, too, sometimes employed unusual croppings or daring perspectives that seemed to anticipate photographic effects. While etchers tended to add elements to heighten the visual drama of a scene, photographers were in no position either to add or subtract anything. MacPherson did not interpret Rome, he marvelled at it. W. W.

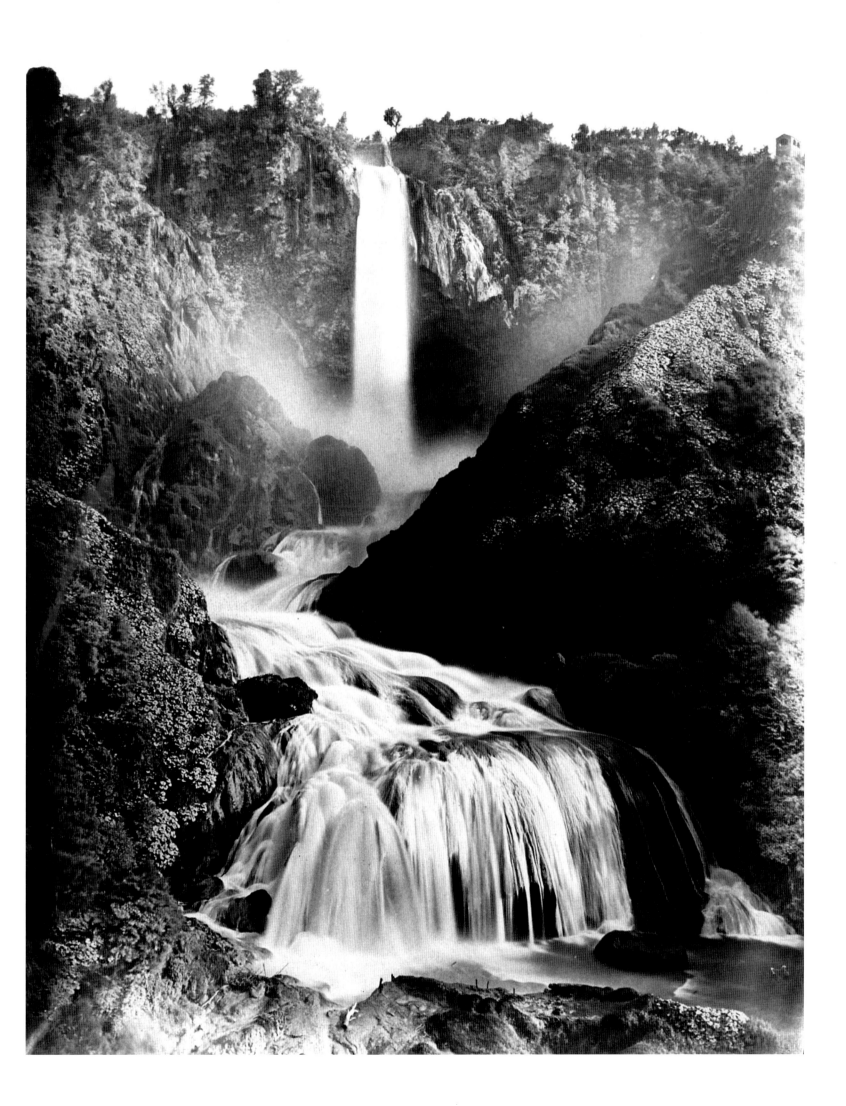

Robert Howlett

ROBERT HOWLETT
1831–1858

was one of the first professional photographers in London. He distributed a darkroom tent that he had designed and was the author of the publication *On the Various Methods of Printing Photographic Pictures upon Paper, with Suggestions for Their Preservation* (1856). His premature death at the age of twenty-seven is attributed to the toxic gases to which he was exposed during his photographic experiments.

Isambard Kingdom Brunel 1857

Valley of the Mole is the title of an 1855 photograph by Robert Howlett that shows an oxcart on the shallow shore of a lake—a picturesque motif verging on sentimentality, in the style of the English watercolorists of the day. Two years later, Howlett's pictures took a different direction. He left behind the limited framework of a sentimental, romantic art and, with his 1857 series on the docks in the East End of London, embarked upon a new genre—photoreportage.

In more than a dozen photographs Howlett recorded the construction of the then largest steamship in the world, *Leviathan*, later renamed *Great Eastern*. Picturesque effects have been entirely banished from these images. In the powerful precision machinery, Howlett recalled the precise nature of his own mechanical art. His general views recorded the ship's skeleton and components, and the men who worked on them. Only in his portrait of the ship's builder, Isambard Kingdom Brunel, standing in front of chains on the ramp down which *Leviathan* would soon be launched, did a glimmer of boldness shine through.

Brunel had already built several large railroad stations and suspension bridges, as well as the steamships *Great Britain* and *Great Western*. The social reformer Samuel Smiles had described him as "the very Napoleon of engineers, thinking more of glory than of profit, and of victory than of dividends." Standing with relaxed composure at the construction site, oblivious of his dirty clothes, Brunel set the dominant key for a coming generation of figureheads—technicians and engineers.

Howlett's photographs were published on June 16, 1858, in *The Illustrated Times*, reproduced using the wood-engraving technique, which was still common practice at that time in the newspaper printing industry. F. L.

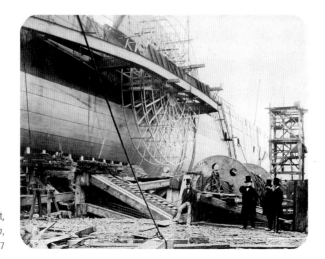

Robert Howlett,
SS Great Eastern,
1857

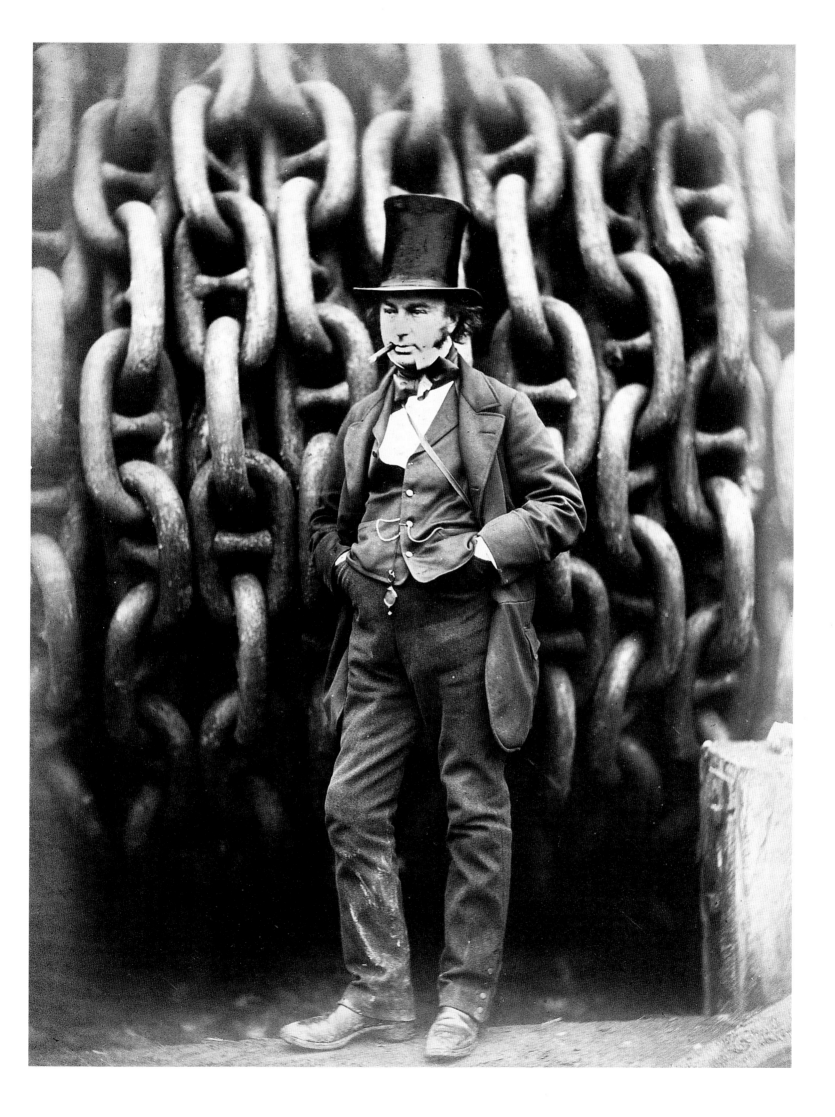

Julia Margaret Cameron

Sir John Herschel 1867

JULIA MARGARET CAMERON
1815–1879

the first world-ranking woman photographer, was born in Calcutta. After moving to England with her English husband in 1863, she was given a camera as a gift and began — at the age of forty-eight — to photograph as an amateur. In her studio on the Isle of Wight she portrayed numerous celebrities of the period and, with the aid of servant girls and neighbors' children, arranged scenes inspired by Pre-Raphaelite art. Her often purposely out-of-focus large-format images transcended every technical convention of photography. In 1875 she moved with her husband to Ceylon (now Sri Lanka), where they ran a coffee plantation.

Even if we did not know that John Herschel was a famous man in his day, we cannot help but be struck by the extraordinary aesthetic quality of the present portrait. The astronomer, who was virtually a universal genius and played a role in the invention of photography, is shown in the pose of one of Rembrandt's biblical figures. A beret in the style of Rembrandt and velvet cloak would normally have been the favorite studio props of many nineteenth-century artists and photographers. Yet the photo was not taken in Julia Margaret Cameron's studio, but, as she noted, at the sitter's own residence in Collingwood. The facial expression of the seventy-five-year-old man, who looks much older than people of his age today, banishes any thought of a consciously assumed pose. His features convey a childlike curiosity, kindness born of experience, and evident weariness, which combine into an expression of the wisdom of old age.

For the photographer, who portrayed many English poets, artists, and scholars, her friend's features were a stroke of luck, so perfectly did they conform to her Rembrandt-based ideal of manliness. Young women on the other hand, whose pictures she took even more frequently, resembled the languishing beauties of Pre-Raphaelite painting. Religious allusions held a great appeal for Cameron. *The Kiss of Peace* for instance being exchanged by a child and Cameron's favorite model, her servant Mary Hillier, is a ritual found in the liturgy of all Christian confessions. W. W.

Julia Margaret Cameron
The Kiss of Peace, 1869

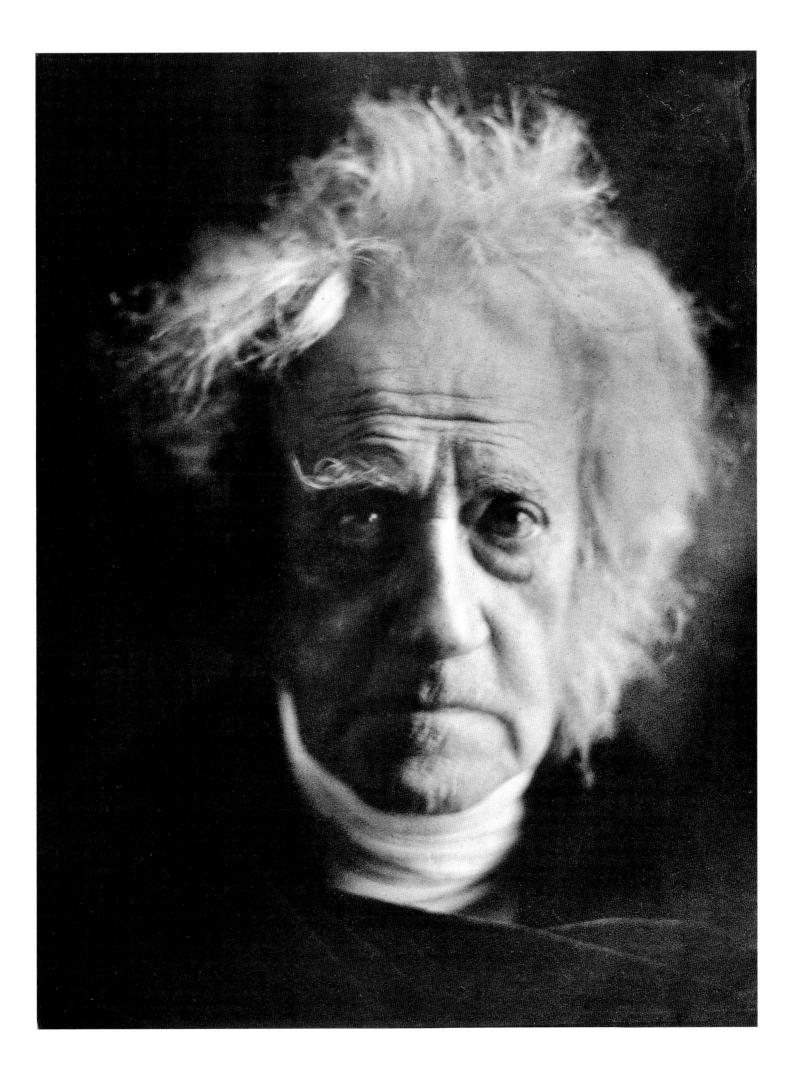

Clementina Hawarden

The Toilette *c.* 1864

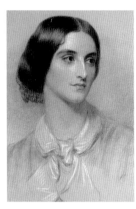

CLEMENTINA HAWARDEN
1822–1865

was born on a country estate near
Glasgow, Scotland. She married Lord
Hawarden in 1845, and bore ten
children between 1846 and 1864.
She took up the camera in 1857 and
exhibited twice at the London Photo-
graphic Society, winning a silver medal
both times. Lewis Carroll purchased
five of her photographs in 1864. She
died of pneumonia in 1865, at the age
of forty-two.

Reportage photographs reflect a reality that exists only for the brief moment the camera shutter is released. A split second later, and the reality has already changed. In the nineteenth century this was not an issue, since moving subjects were rarely photographed anyway—long exposure times were still necessary then.

All the more seldom can it be guaranteed that old photographs show things as they actually were. Many compositions were carefully arranged, or existing subjects were altered to the point of creating an artificial reality for the camera lens. People were asked to stand in front of a building to resemble the people in a painting; still lifes were arranged on tables until the photographer was aesthetically satisfied with the result; and people who had their portraits taken were encouraged, as they still are today, to smile for the camera, irrespective of how they were really feeling.

The artificial world of theater long eluded photography simply because the stage lighting was too dim. Yet the amateur performances known as *tableaux vivants*, or "living pictures," a popular pastime in aristocratic and middle-class circles, could easily be staged in broad daylight. Alongside Julia Margaret Cameron, Lady Hawarden was the virtuoso photographer of such scenes. Unlike her rival, she avoided recreating literary scenes. Simply by positioning her subjects in a certain way, Hawarden suggested clandestine little dramas between the sexes. The posed photographic tableaux of contemporary artists such as Cindy Sherman and Jeff Wall owe something to Hawarden's keen sense of effect.

W. W.

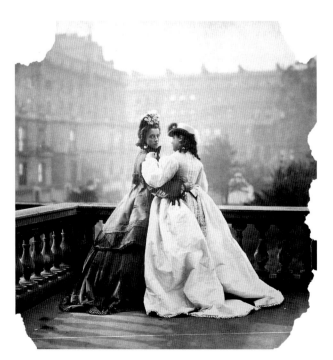

Clementina Hawarden,
On the Balcony, 1860/64

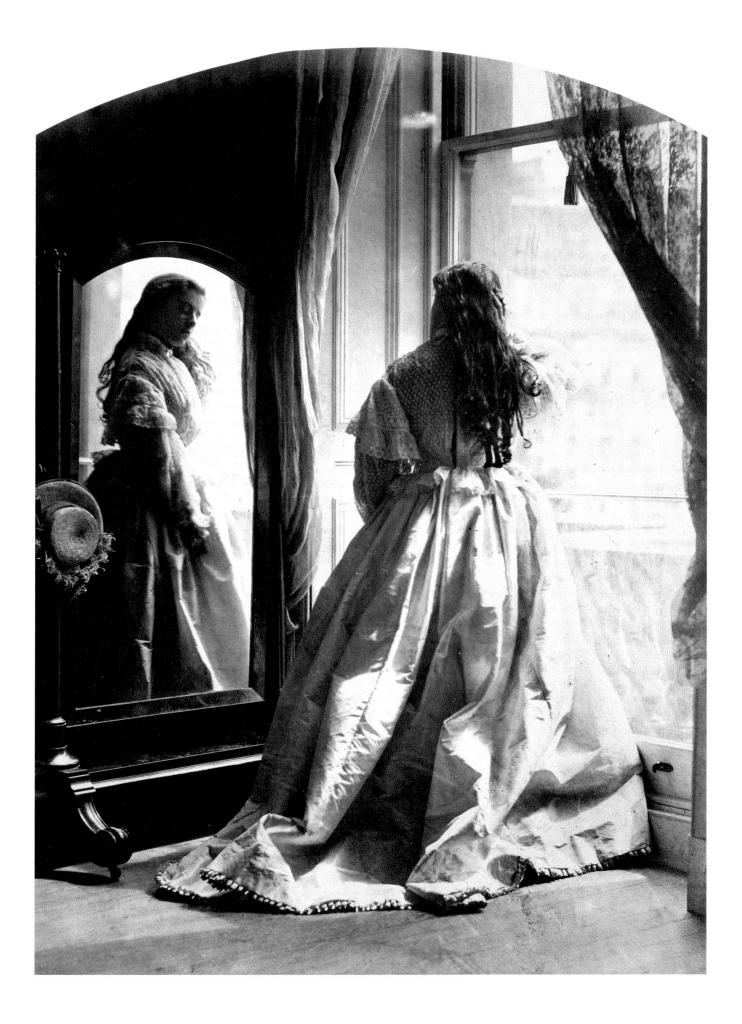

Lewis Carroll

Alexandra "Xie" Kitchen as "Tea Merchant" 1873

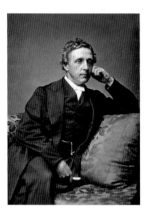

LEWIS CARROLL
1832–1898

was born as Charles Dodgson in Daresbury in Cheshire, England. He spent his life as a theologian and mathematician at Christ Church College, Oxford. Assuming the pseudonym Lewis Carroll in 1856, he achieved worldwide fame for his novels *Alice's Adventures in Wonderland,* 1865, and *Through the Looking-Glass and What Alice Found There,* 1871. He started taking photographs in 1856 and, according to his journals, continued to do so until at least 1880.

He was a clergyman, mathematician, author, and photographer. Above all, Lewis Carroll was an enigmatic personality whose secrets countless commentators have attempted to unravel. Just as mysterious as his childishly playful and symbolically encoded novels are many of the amateur photographs he took of little girls. By his own account, boys and adults interested him far less, and as soon as the girls reached puberty, his admiration too rapidly dwindled. A sentimental eroticism doubtless played a role in his photographic hobby, especially in view of the many nudes he took, only four of which have survived. Victorian society was far less troubled than present-day society would be with such photographs, almost all of which were made with the permission of the girls' parents. Ever since Sigmund Freud taught us to translate erotic allusions into straightforward sexual terms, we have increasingly lost our sensitivity to the allusions and symbols that were typical of the nineteenth century. Carroll enjoyed dressing up his favorite models and letting them playfully slip into adult roles. Alexandra Kitchen, nicknamed "Xie," poses here as a slightly apprehensive "tea merchant," and Alice Jane Donkin pretends that her bridegroom is waiting below to spirit her away from her parents.

W. W.

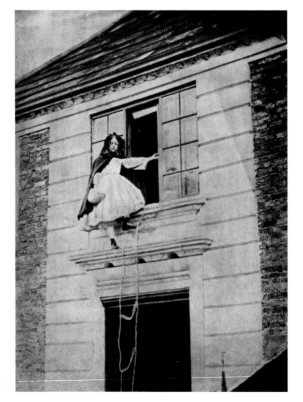

Lewis Carroll,
The Elopement, 1862

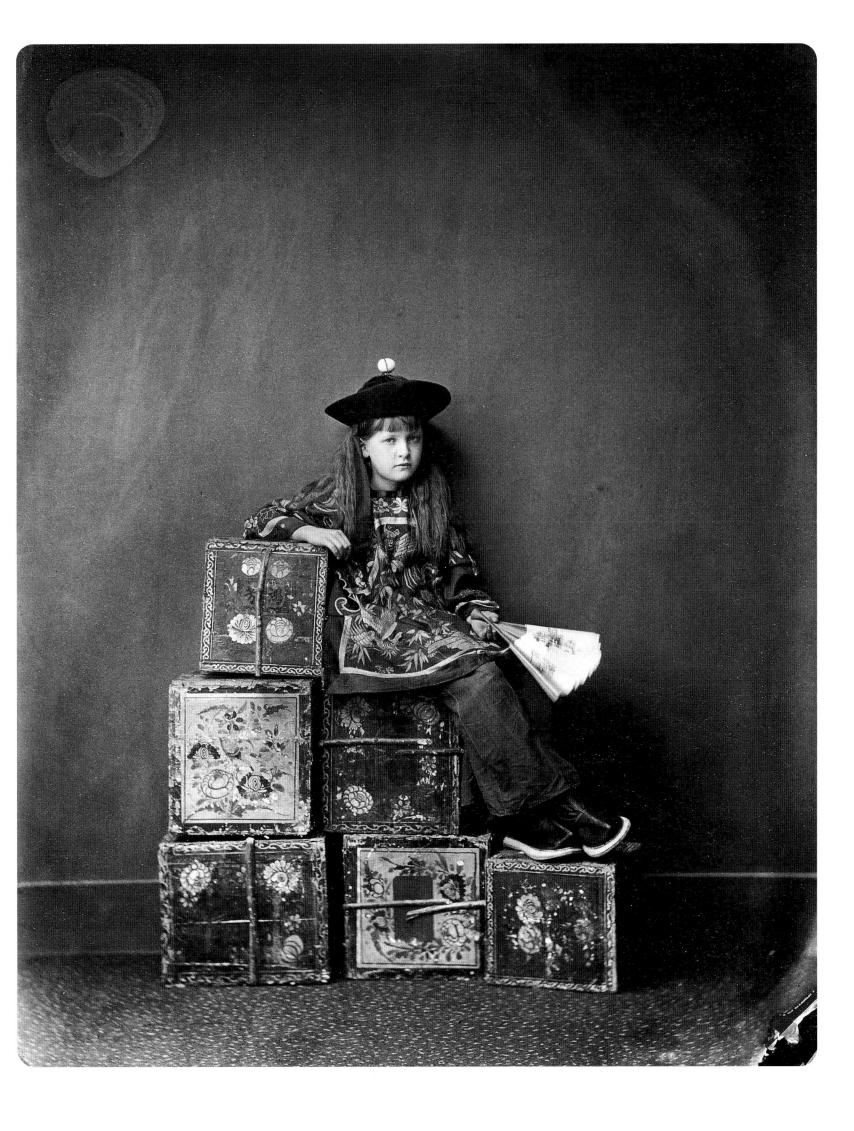

Félix Nadar | Adrien Tournachon

The Mime Debureau in Pierrot Costume 1854/5

FÉLIX NADAR

■ 1820–1910

was born as Félix Tournachon in Paris. Under the pen name "Nadar," he became a successful caricaturist. An advocate of revolutionary views, he took up photography in 1854 in order to help his younger brother, Adrien, a failed painter. It was Adrien who garnered the praise given to their jointly produced Pierrot series at the 1855 World Fair. Nadar became the most original photographer in Paris, made pioneering aerial photographs from a balloon, and worked with artificial light in the catacombs. Nadar's studio was the site of the Impressionists' first exhibition, in 1874.

Popular theater was the cinema of the nineteenth century. But before the invention of electric light and more sensitive negatives, stages remained no-go areas for photographers. They resorted to reconstructing dramatic scenes in the studio. Nadar, for a time the most famous photographer in Paris, gave one of his most virtuoso performances in a series devoted to the young Debureau in the role of Pierrot.

The pantomime Charles Debureau essentially continued the art of his father, the renowned Baptiste Debureau, who was immortalized in Marcel Carné's film *Les Enfants du Paradis*. Nadar, assisted in this series by his younger brother, Adrien Tournachon, instinctively recognized that the striking Pierrot figure and the gestures of pantomime were perfectly suited to photographic reproduction. The white of the costume would stand out wonderfully against a dark background; viewers would accept the exaggerated poses because they were used to seeing them on stage; and the figure's silence would be no problem because it was an essential element of his art.

In the pantomime of the two Debureaus, the *Commedia dell'arte* figure of the luckless Pierrot was recast into the comedy figure of the suffering artist who is nonetheless condemned to laughter. Debureau was the Chaplin of the nineteenth century. Such fame was later enjoyed by the eccentric and ambitious Sarah Bernhardt, whose expressive style in classical roles was imitated for decades in many countries.

W. W.

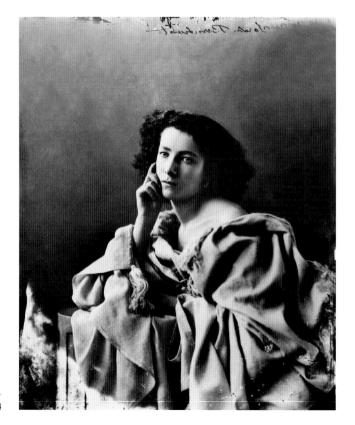

Nadar, *Sarah Bernhardt,* 1864

46

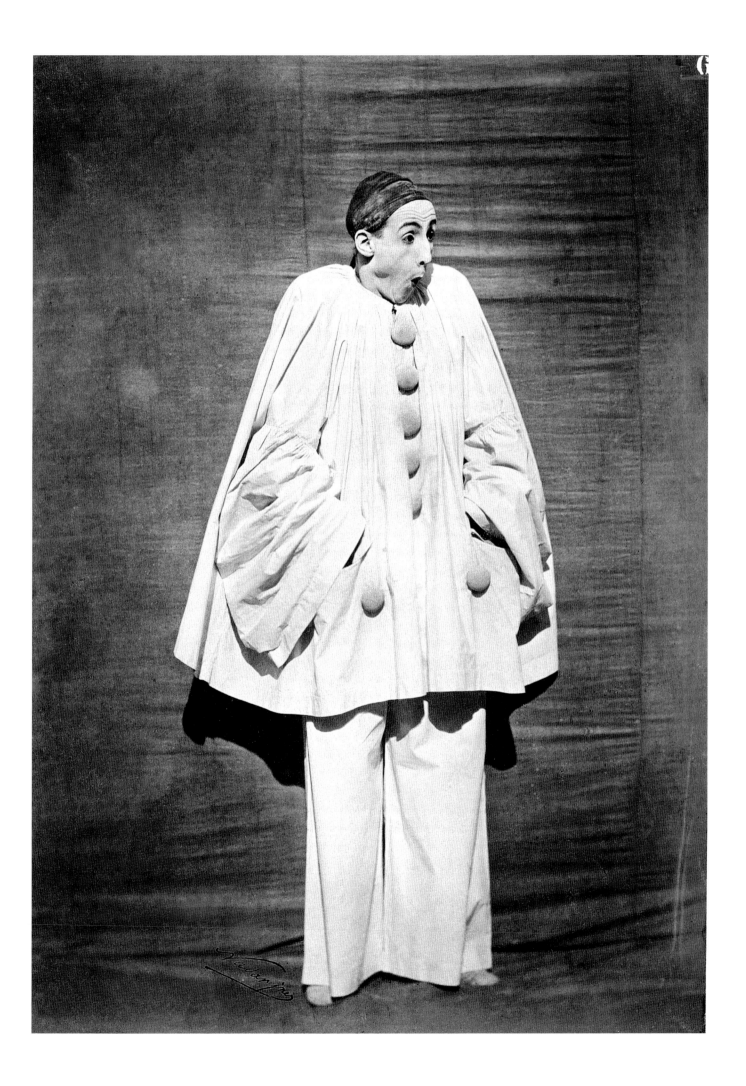

Mayer & Pierson

Comtesse de Castiglione *c. 1864*

PIERRE-LOUIS PIERSON
1822–1913

was a daguerrotypist from 1844. Ten years later he entered a partnership with the brothers Leopold Ernest and Louis Frédéric Mayer. Their two Paris studios, run under the name of "Mayer & Pierson," counted the royal family and members of the aristocracy among their clients and produced a photographic gallery of famous contemporaries. Until the 1860s they were among the most prominent addresses in the field.

Countess Virginia Castiglione (1837–99) came to Paris in 1855 on a mission to use her family ties to further Italian unification. She soon struck up an acquaintance with Napoleon III, and became one of the French Emperor's favorites. Affairs with leading men in politics and business assured her of a certain influence, and her many escapades and eccentric lifestyle made the countess a prominent figure in the Second Empire. Her fame was due partly to the many photographs of her that came into circulation. Alongside stars of the stage, the countess was among the most photographed women in France. She was photographed by Pierre-Louis Pierson alone four hundred times.

Here the countess poses with a passe-partout in the tradition of those paintings of eighteenth-century ladies who cast a coquettish look at the observer from behind a fan. At the same time, the fragmentary nature of photography—the way it simultaneously reveals and conceals—is emphasized by a prop used to present a picture while partially covering it, leaving it up to the viewer's imagination to complete the hidden portions. The countess, famous for her extraordinary beauty, turns the voyeurism of the period back on the observer by retiring behind a veil and fixing the public with an inquisitive eye. T. S.

Mayer & Pierson,
The Majestic Prince, c. 1859

Eugène Durieu

Nude Study 1854

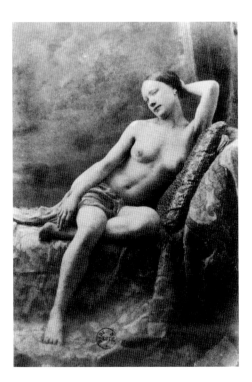

Eugène Durieu, *Model for "Odalisque"
by Delacroix,* 1854

EUGÈNE DURIEU

1800–1874

was born in Nîmes, studied law, and
from 1848 was responsible for church
architecture in the French Ministry of
the Interior. In 1845 he collaborated
with the daguerrotypist Baron Gros,
and in 1850, went into early retirement
in order to devote himself entirely to
photography. Many of the photographs
for his artist friend Delacroix are dated
up to the mid 1850s.

When Paul Delaroche was shown a daguerreotype for the first time in Paris, he reputedly exclaimed, "From today on, painting is dead." Delaroche was a respected history painter whose canvases give little indication of the keen interest he apparently had in photography. In fact, his students in the early 1840s included Gustave Le Gray (see p. 35), Charles Nègre (see p. 26), Henri Le Secq, and the Englishman Roger Fenton (see p. 62), all of whom subsequently became famous photographers.

Nor do the paintings of the great Romantic, Eugène Delacroix, reflect the intensity of his involvement with photography. His diary notes alone reveal that he maintained a close collaboration with the amateur photographer Eugène Durieu and based drawings on his photographs. Delacroix owned an entire album of Durieu photographs, and it cannot be ruled out that he occasionally helped to arrange the models. The artist's relationship to photography was divided. Although he supported the new medium in public, he tacitly considered it merely a handmaiden to art and used Durieu's photographs clandestinely.

Incidentally, Durieu's taste in art was quite uncertain. In addition to naturalistic compositions that almost look like models for Gustave Courbet's canvases, there are stylized nudes that recall the ideal of beauty of the Classicist Ingres, Delacroix's arch rival. Rather than attempting to create his own style, the photographer oscillated between those currently in vogue. W. W.

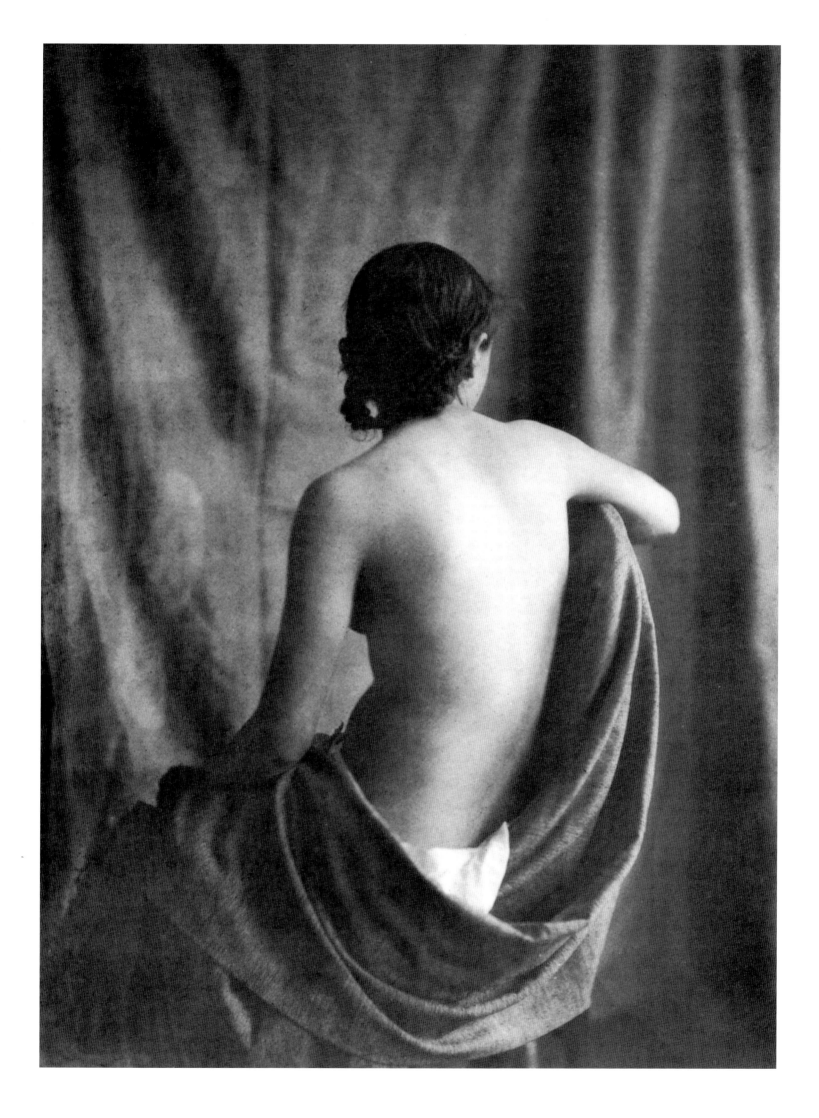

Franz Hanfstaengl

Leo von Klenze, Royal Building Superintendent 1856

FRANZ HANFSTAENGL

◼ 1804–1877

studied at the Art Academy in Munich
and became a successful lithographer
specialising in the reproduction of
works of art. In 1852 he switched to pho-
tography, probably under the tuition of
Alois Löcherer. His portrait photographs
brought him international acclaim. His
technique for touching up negatives in
such a way as to be virtually invisible to
the naked eye was much admired.
Hanfstaengl also founded a well-known
art publishing house in Munich.

Franz Hanfstaengl used his increasing popularity to photograph as many of the day's outstanding figures as he could. In 1854 he began collecting these portraits in an *Album of Contemporaries*, selling the photographs individually, as the series was never finished. The project may have been partly inspired by the architect Leo von Klenze's hall of fame, "Valhalla," with its marble busts of famous Germans. Hanfstaengl's principal model, however, was the *Photographic Album of Contemporaries* produced by Alois Löcherer of Munich (see p. 24). Such albums continued a centuries-long tradition of painted, chiseled, or engraved series of portraits of famous personalities. The century's most renowned photographic portrait collection was *Galerie contemporaine*, published in Paris from 1876 to 1884.

Hanfstaengl's portrait of Leo von Klenze at seventy-two is a perfect example of a style that made lavish use of Old Master portrait techniques. The traditional column as a symbol of mastery, the Greco-Roman ornament, the theatrical drapery, and the medal are all accessories intended to elevate the sitter. Yet his gaze, modestly turned away from the viewer, and the expanse of empty space above the figure, signal an unpretentiousness that was entirely the work of the photographer.

W. W.

Franz Hanfstaengl,
King Maximillian II of Bavaria,
Munich, *c.* 1856

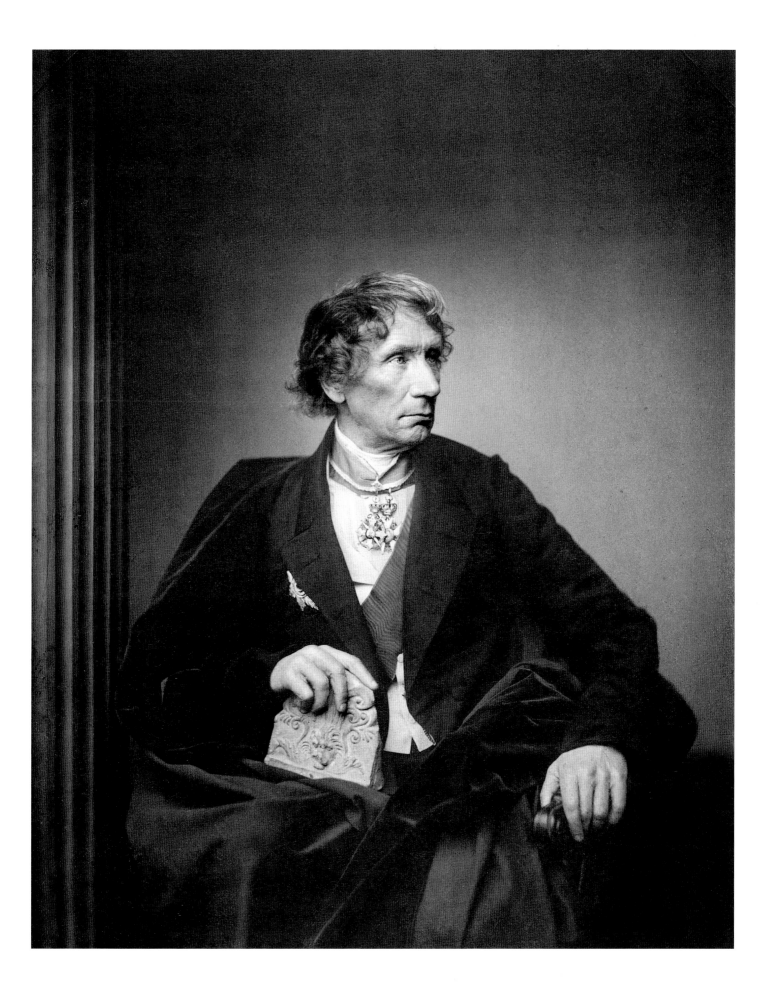

Étienne Carjat

ÉTIENNE CARJAT
▪ 1828–1906

was a versatile figure in the Paris of the 1850s—a caricaturist, writer, and magazine publisher of outspoken republican sentiments. He opened his first photographic studio in 1861, specializing in portraits whose precision was admired by his friend, Nadar.

Charles Baudelaire *c.* 1862

Victor Hugo, the most renowned French writer of the nineteenth century, was still alive when the poet Théodore de Banville held a funeral oration for his friend, Charles Baudelaire, in Paris in 1867. Banville divided literature into two epochs. Hugo, he said, was the last representative of the old era, which idealized humankind, whereas Baudelaire was the first poet of the modern age, which showed people with all their contradictions. This insight still holds today, and thanks especially to the analyses of Walter Benjamin, Baudelaire has long been recognized as the quintessential prophet of the modern world.

His outward appearance confirms Banville's description—both sensitively vulnerable and ironically superior. While portraits by Nadar strongly emphasize the poet's vain, foppish side, Carjat depicts the forty-one-year-old in the pose of a lonely intellectual who, bothered by all this picture-taking business, looks into the camera with an impatient and distrustful expression. Yet this very picture was to become the most renowned of all Baudelaire portraits.

The reproduction published posthumously, in 1878, in the popular anthology *La Galerie contemporaine* guaranteed it a wide circulation, and it has been continually reproduced down to the present day. Among the many nineteenth-century portraits, Carjat's Baudelaire has become an outstanding icon. W. W.

Étienne Carjat, *Arthur Rimbaud,* 1872

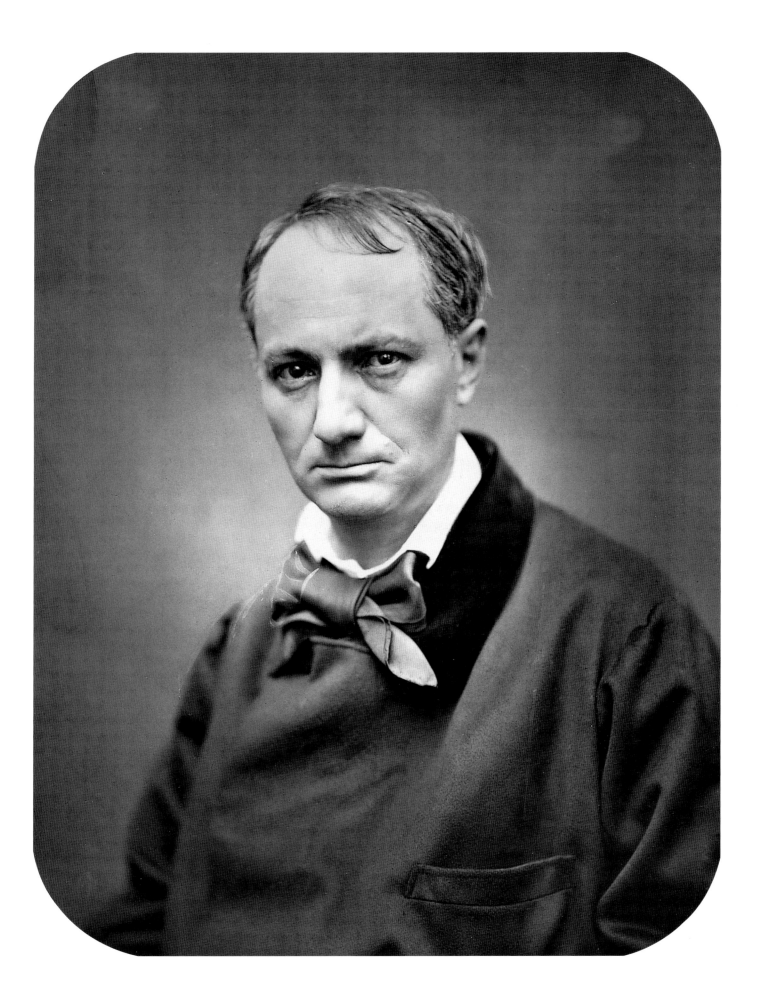

Franz de Paula Antoine

Franz de Paula Antoine, *Still Life with Armor*, 1859

The Rose of Jericho (Anastatica Hierochuntia)
c. 1860

Leaves or other parts of plants played a key role in the experiments of almost all the inventors of photography and their predecessors. They either placed them on light-sensitive paper and exposed them to sunlight to obtain an impression, or prepared sections and put them under a microscope for exposure. When reproduction of photographic images became possible, botanists were among the first to employ the medium for classification and publication.

One of these plant-lovers was Franz de Paula Antoine, whose employment as a gardener at the Royal Parks of Vienna involved a talent for arrangement. This proved an advantage when it came to depicting botanical subjects as a scientist and photographer. He used a holder to position the plants in front of the camera, and made use of the techniques of presentation and emphasis to highlight both the expressiveness of museum presentation and the museum character of photography, which conserves a certain state and allows the resulting reproduction to be incorporated in a rich and comprehensive collection of imagery. T. S.

FRANZ DE PAULA ANTOINE

(1815 – 1886)

came from a family of gardeners, studied landscape drawing at the Vienna Academy, and took courses in botany. After study trips through Europe, he worked at the Hofburggarten in Vienna, became court gardener in 1841, and director of court gardens in 1865. An amateur photographer, he made studies of plants which he used to illustrate his own books. In addition, he photographed still lifes and views of Vienna, for some of which he employed the stereoscopic format.

Hermann Krone

Basteibrücke (Bastion Bridge) 1857

HERMANN KRONE
■ 1827–1916

After serving an apprenticeship and traveling for some years, Hermann Krone opened a photographic studio in Dresden in 1852, where he would remain throughout his life. A portrait, architecture, and landscape photographer, he experimented with almost every photographic technique of the day, from daguerreotype and calotype to late pigment and phototype prints. Since he considered himself as much a researcher as a practicing photographer, he viewed his *Historisches Lehrmuseum für Photographie* (Historical Teaching Museum of Photography) as his true major work. While teaching at Dresden Polytechnic, he worked on a total of one hundred and thirty-seven large-format plates in 1893. Based on samples of Krone's own work, they illustrated the technical development of photography.

When Hermann Krone set out from Dresden on his "first photographic landscape tour" in the fall of 1853, the bizarre rock formations in the area known as Saxon Switzerland had long since become a set piece of German Romanticism. Caspar David Friedrich, Carl Gustav Carus, and Ludwig Richter had drawn and painted them; Hans Christian Andersen had described his travels there in detail; and Carl Maria von Weber had discovered the Wolf's Glen for his opera the *Freischütz* there. So it was by no means a wilderness that Krone photographed, but a region developed for tourism. Rocky pinnacles were connected by bridges, and plateaus had been converted into viewing points. Innkeepers dammed brooks and, for a small fee, let them rush over outcrops as waterfalls. Some guesthouses even provided dance floors for their customers.

Krone took photographs for tourists in the mountains outside Dresden for almost half a century. He sold his prints as cabinet pictures, mounted on heavy card with gold edging, as foldouts, and postcards. They were souvenirs, on which the tourists themselves were often seen. Despite the motifs they shared with Romantic painting, Krone's images rarely evinced Romanticism's typical gloominess fraught with symbolism. He captured moments of tranquility in a domesticated landscape.

F. L.

Hermann Krone, *Court Church and Opera House, Dresden,* before 1869

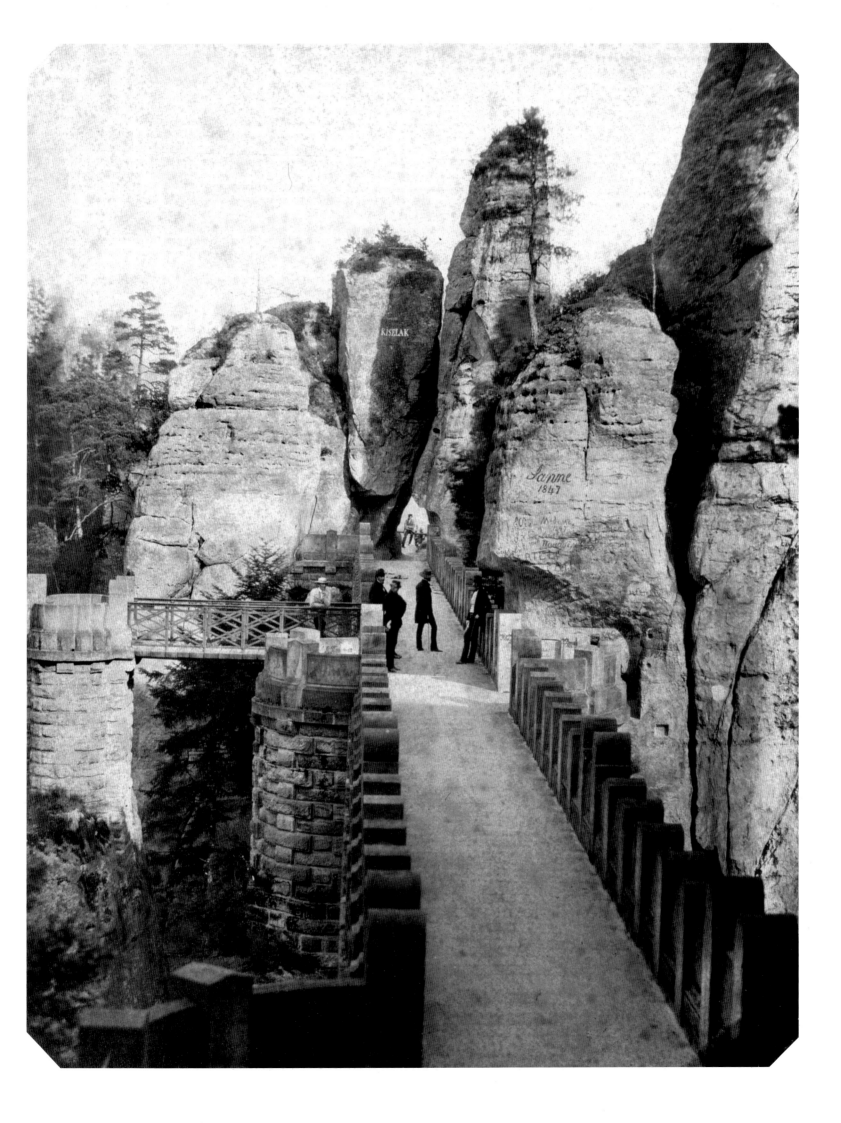

August Kotzsch

AUGUST KOTZSCH
1836–1910

grew up in the village of Loschwitz near Dresden, where many artists lived. One of them lent his photographic equipment to Kotzsch in the late 1850s, and by 1861 he was already working on a commercial basis. He took pictures of family members and acquaintances at work or in posed settings. He developed a penchant for picturesque scenes of everyday village life and the surrounding landscape, which were in demand by painters and draftsmen as models for their work. While his close-ups of fruits, flowers, and foliage tended to idealize, Kotzsch's direct approach amounted to a special personal contribution to the history of the medium.

Cut Melon *c.* 1870

Still life initially served the pioneers of daguerreotype and photography as a testing ground for experiments involving the changing effects of light or the limits of optics. They generally set plaster casts of sculptures and reliefs, or various everyday utensils, on a table without much concern for composition. Soon, however, photographers with a more aesthetic bent began to create arrangements of flowers, old armor, and other objects, often inspired by early Flemish and Dutch painting.

Only gradually did individual photographers begin to discover the intrinsic strengths of the medium and employ it more ingeniously. They brought the camera very close up to their subjects in order to capture their special character in sharp focus, down to the tiniest detail. A few photographers exploited the potential of the medium to approach their subjects extremely closely, emphasizing their characteristics in sharply focused detail. Things now began to stand for themselves, regardless of their origin or use, unfolding a poetry of simplicity of a strange, sometimes cold beauty. This staging and description of isolated appearances sprang from a specifically photographic perception that also informed the literature of the latter half of the century, and that would influence still-life painting as well. Such close-ups ultimately found a wider application in the sober imagery of the New Vision of the 1920s. T. S.

August Kotzsch,
*Daddy Longlegs Taking
his Leave, c.* 1878

60

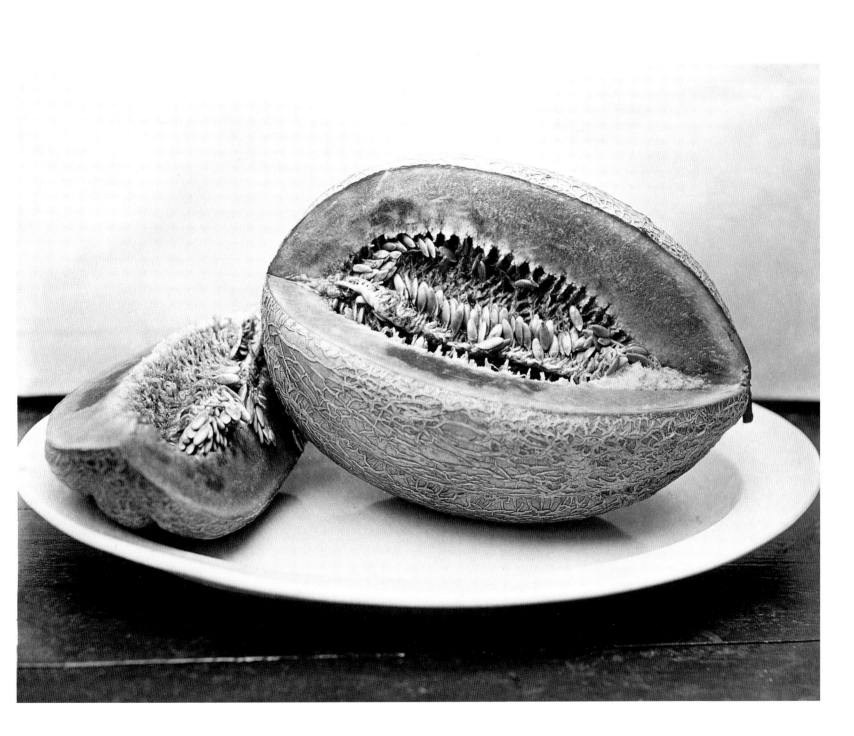

Roger Fenton

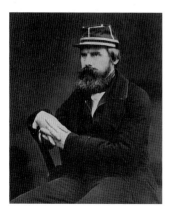

ROGER FENTON
■ 1819–1869

studied law and practiced as an attorney in London. In 1841 he attended an art course in the studio of Henri Delaroche in Paris and continued to paint after returning to London. After coming into contact with photography in 1851, the following year he brought back topographic views from a trip through Russia. In preparation for recording the Crimean War he equipped a wagon with all the necessary utensils. On site, he portrayed mainly British officers, but he also photographed army positions, ships being unloaded, field hospitals and wounded men, resulting in one of the earliest photo-reportages. In architectural and landscape photographs Fenton pictured England in a grand and romantic manner, just as his genre studies and still lifes were inspired by past eras in painting.

The Queen's Target 1860

The best way to record an ongoing event is to shoot it from different viewpoints and at various moments. Yet while processes extend over a certain time period, photography, a static medium, is capable only of capturing single, isolated moments. In order to compensate for this drawback, photographers have always tried to focus on the final moment of an event. In cases where the camera cannot be present or the seminal moment eludes it, they tend to select a motif in which the event finds its most characteristic precipitation. Among the best known photographs of this kind is that of Emperor Maximilian's shirt — its bullet holes provide graphic testimony to his execution in 1867 in Mexico.

Roger Fenton had similar experiences when photographing the Crimean War. His photograph *The Valley of the Shadow of Death*, 1855, witnesses a past battle that has left nothing in its wake but a barren rocky wasteland and scattered cannon balls. In the same way, the meaning of his picture of a target becomes clear only when we are aware of the context in which it was made. It records the marksmanship demonstrated by Queen Victoria at a shooting meet. Admittedly her rifle was clamped on to a stand and pointed straight at the bull's-eye, so, to hit it, all she had to do was pull a string. This apparatus, too, was captured by the photographer, without showing any of the persons involved. The culminating moment remains invisible—it lay between two clicks of the shutter.

T. S.

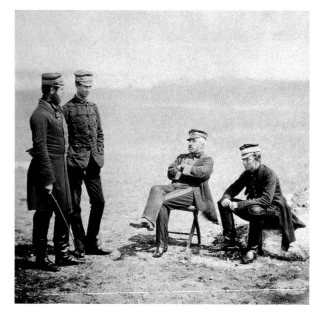

Roger Fenton,
*Lieutenant-General Barnard
and Officers, Crimea,* 1856

Bisson Brothers

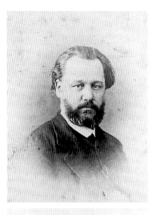

LOUIS-AUGUSTE BISSON
1814–1876

AUGUSTE-ROSALIE BISSON
1826–1900

Louis-Auguste Bisson opened a photographic studio with his father immediately after the invention in 1841 of the daguerreotype. Yet his real breakthrough came with a studio jointly established in 1852 with his brother, Auguste-Rosalie Bisson, where they employed up to thirty assistants. Their Paris address became a gathering place of artists and intellectuals. The two brothers took many trips through France, Belgium, Germany, and Italy, photographing castles, cathedrals, and other architectural monuments on very large formats of up to 20 × 44 inches in size.

"La Crevasse," Ascent of Mont Blanc 1862

A scientific project brought the Bisson brothers, Louis-Auguste and Auguste-Rosalie, to the Alps in the mid 1850s. Daniel Dollfus-Ausset, an industrialist and glaciologist, commissioned them to photograph mountain ranges, peaks, and glaciers. During this commission they broke with the current conventions of landscape photography. Their images were sober and straightforward records of topography, not idealized compositions. Some were over three feet wide. They caused a sensation.

Auguste-Rosalie Bisson, the younger of the two brothers, found the mountains irresistible. He felt he had to climb Mont Blanc. After two failed attempts, he scaled the peak in summer 1861, and again in spring 1862. Twenty-four porters and guides helped him carry his camera and glass plates, a darkroom tent, and all the necessary chemicals to an altitude of nearly sixteen thousand feet. The photographs he took turned out to be far more spectacular than the earlier ones.

As tiny dots in a broad panorama of snowfields, or caught between the walls of a narrow crevasse, Bisson's companions were photographed in a forbidding icebound world, like ants, proceeding step by step. Heroic yet forlorn, the climbers silhouetted against the blinding white snow took on the appearance of characters in a drama.

When he returned to Chamonix, at the foot of Mont Blanc, Bisson was regarded as a hero, and fireworks were let off in his honor. The public, however, showed little interest in his photographs. They sold poorly, and the costly expeditions brought about the bankruptcy of the brothers' ailing photographic studio in 1863, instead of financing it as they had hoped. F. L.

The Bisson Brothers,
Facade of Rheims Cathedral,
c. 1855

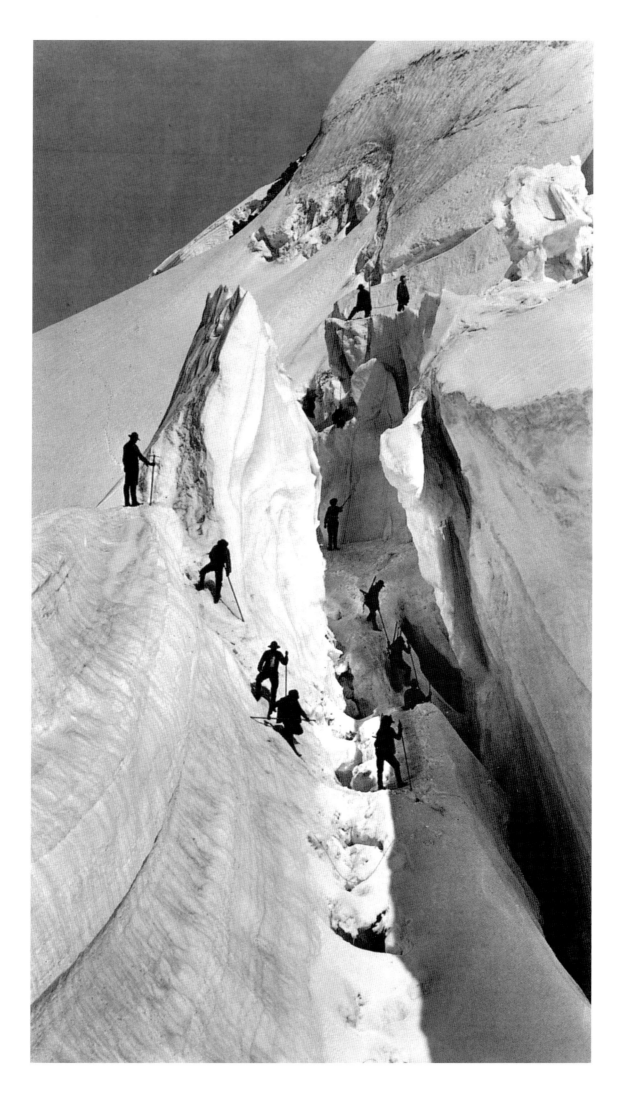

Mathew Brady

President Lincoln at Sharpsburg October, 1862

MATHEW BRADY

1823 – 1896

opened a photographic studio in 1844. It was so successful that in 1850 he was able to publish a portfolio called *The Gallery of Illustrious Americans,* from which hardly a famous contemporary was absent. For a similarly ambitious project Brady hired a team of twenty photographers to record the Civil War—an undertaking that reputedly cost one hundred thousand dollars. It led to Brady's ruin. Deep in debt and half blind, he ran a small studio in Washington until the 1890s, when he was forced to enter a poorhouse.

Two separate chapters in the history of nineteenth-century photography could be devoted to Mathew Brady. One chapter would show prominent men, authors, philosophers, and politicians posing straight-backed and stern-faced in front of velvet curtains in the flattering light of the studio. In the other chapter we would see images of sheer survival on Civil War battlefields under the harsh light of the sun troops slogging through the mud, generals on horseback, pyramids of cannon balls, and nameless cadavers, sprawled like slaughtered cattle in the trenches.

Mathew Brady was America's finest portrait photographer and a visual reporter on the Civil War. And, like his work, it would seem as if his personality had been divided. In New York and Washington, he played the role of bohemian host to high society in two spacious, lavishly furnished studios. On the front lines of the Civil War, he was the complete adventurer. This is the impression conveyed by his photographs, and it was one he himself often consciously strove to make.

Yet an even better analysis of Brady would be to call him a visionary businessman. Very few of his hundreds of thousands of prints were actually taken by him, despite the fact that they all bear his name. He had employees to whom he gave strict instructions and whom he schooled in his aesthetic of the harsh, cold style. They included Timothy O'Sullivan (see p. 68) and Alexander Gardner, who would later become famous in their own right. "Brady" was a company, a brand name.

At the meeting point of his two, broad themes we find numerous portraits of Abraham Lincoln. Brady began to photograph Lincoln long before he was elected president in 1860, and reputedly his portraits had a great influence on the election results. After the election, he invited the president to his studio many times and accompanied him to the scenes of war. Brady, in fact, shaped the image of Lincoln as a strict, ascetic man. One of these portraits, with its concentrated, aloof facial expression, served as the basis for the famous engraving on the five-dollar bill. F. L.

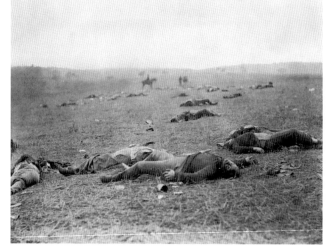

Timothy O'Sullivan,
A Harvest of Death, Gettysburg,
July, 1863

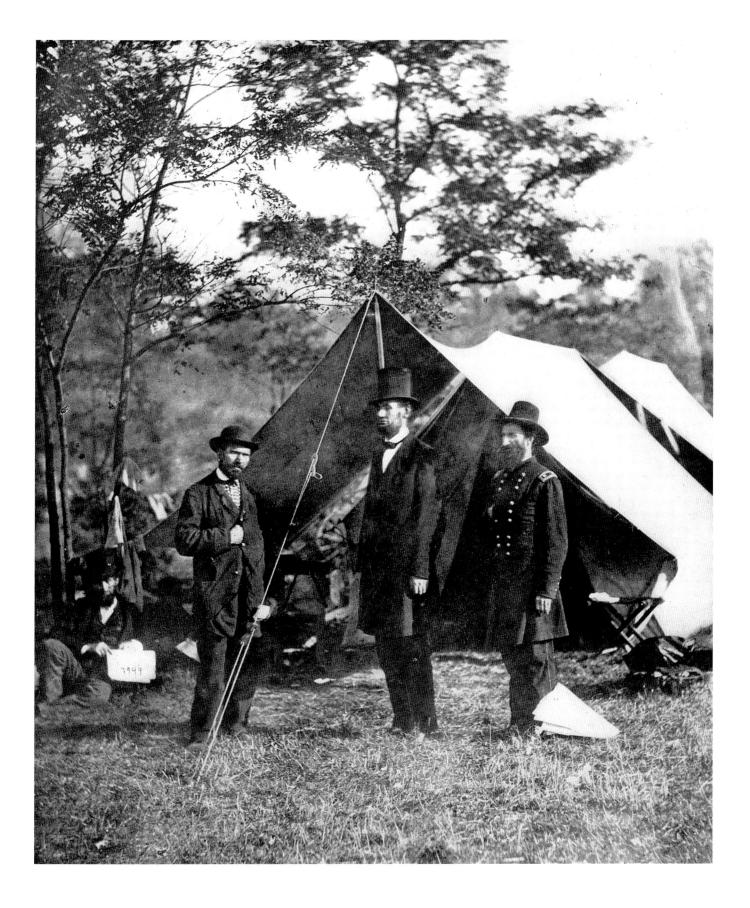

Timothy O'Sullivan

TIMOTHY O'SULLIVAN
■ 1840–1882

was still in his teens when, in the mid 1850s, he began working in Mathew Brady's portrait studios (see p. 66), first in New York and then in Washington. In 1862 he worked for Alexander Gardner and began recording the battles of the War of Secession for him. Between 1867 and 1874 he accompanied research and surveying expeditions through the desert states of the American Southwest, which took him to the Grand Canyon, as well as through Panama, on the search for the shortest route for an ocean-to-ocean canal.

Sand Dune, Carson Desert, Nevada 1867

Timothy O'Sullivan photographed battlefields of the Civil War before accompanying geologists such as Clarence King and George Wheeler on government expeditions through the Wild West. His haunting memories of fields strewn with corpses seeped into his pictures of the prairies, deserts, and mountains west of the Mississippi. O'Sullivan turned his camera on dead buffalo, collapsed mine shafts, or naked, forbidding cliffs in the brilliant light of a merciless sun. Far from the tradition of the picturesque to which other artists of the period adhered, and far from the notion of the West as a paradise regained whose natural wonders were believed to prove the existence of God, O'Sullivan showed a harsh environment where humanity had no place.

Many of his pictures seemed to illustrate Clarence King's catastrophe theory of a world involved in continual self-destruction. And due to their starkness, many of his photographs were considered mere visual accompaniments to King's geological reports. Yet an artistic consciousness can be detected behind the converging lines of sheer cliffs photographed from extreme vantage points, or behind such metaphors as wheel tracks left in the sand by the photographer's darkroom wagon. The dunes that blocked his way to California were like an omen to O'Sullivan. The wilderness itself sent him back home, back east. F. L.

Timothy O'Sullivan, *Historic Spanish Record of the Conquest, Inscription Rock,* 1873

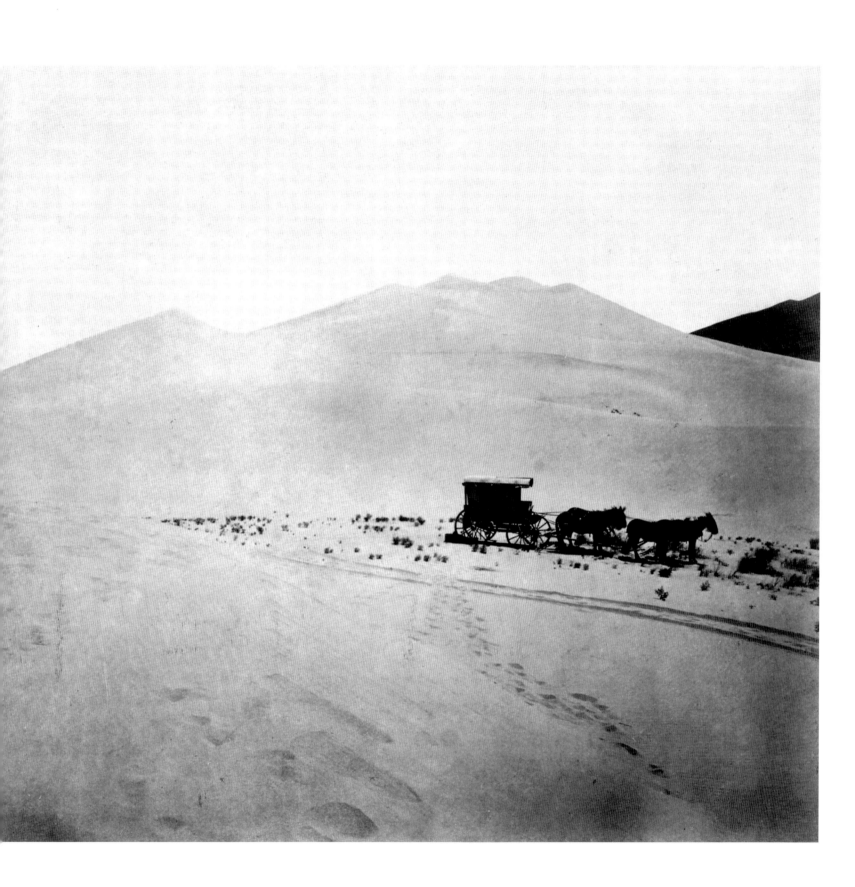

Carleton E. Watkins

CARLETON E. WATKINS
■ 1829–1916

went from New York to California during the Gold Rush. He began to photograph in the mid-1850s, concentrating on landscapes. His famous prints, awarded many international medals, sold for high prices at Watkins's own Yosemite Art Gallery in San Francisco. He also accompanied government expeditions and worked as a photographer for several railroad companies. In the mid 1870s his life took a tragic turn. Watkins lost his fortune, then his eyesight, and finally his mind. In 1910 he was admitted to a psychiatric clinic, where he died six years later.

Yosemite Valley from the Best General View 1866

Not a man to compromise, Carleton E. Watkins believed there was only one ideal point from which to photograph any motif. He called it "the best view," and spared no effort in finding it. From 1861 onwards he traveled over and over again to Yosemite Valley in the Sierra Mountains of California, and each time his camera equipment, strapped to the backs of six mules, was carried higher into the mountains. It included apparatus capable of exposing mammoth format glass plates measuring 18×21 inches. Watkins was striving for moments of eternity, images of order and harmony that would eclipse the confusions of the Civil War, taken from vantage points that would reveal the will of divine creation in the midst of the wilderness. Watkins illustrated what authors of the period meant when they metaphorically designated the American West as a paradise regained and the nation as God's Own Country.

This attitude found its culmination in Watkin's 1866 picture of *Yosemite Valley from the Best General View.* The view across the valley became a view into the promised land, in which the slightly raised camera position gave viewers a sense of physical elevation. The atmosphere of calm was created by copying clouds from another negative into the sky. At a time when American artists and intellectuals attempted to compensate their country's lack of history by appealing to its vast, open spaces, Watkins transported these spaces with such a convincing aesthetical quality that his photographs were shown in the American Hall at the 1867 World Fair in Paris. F. L.

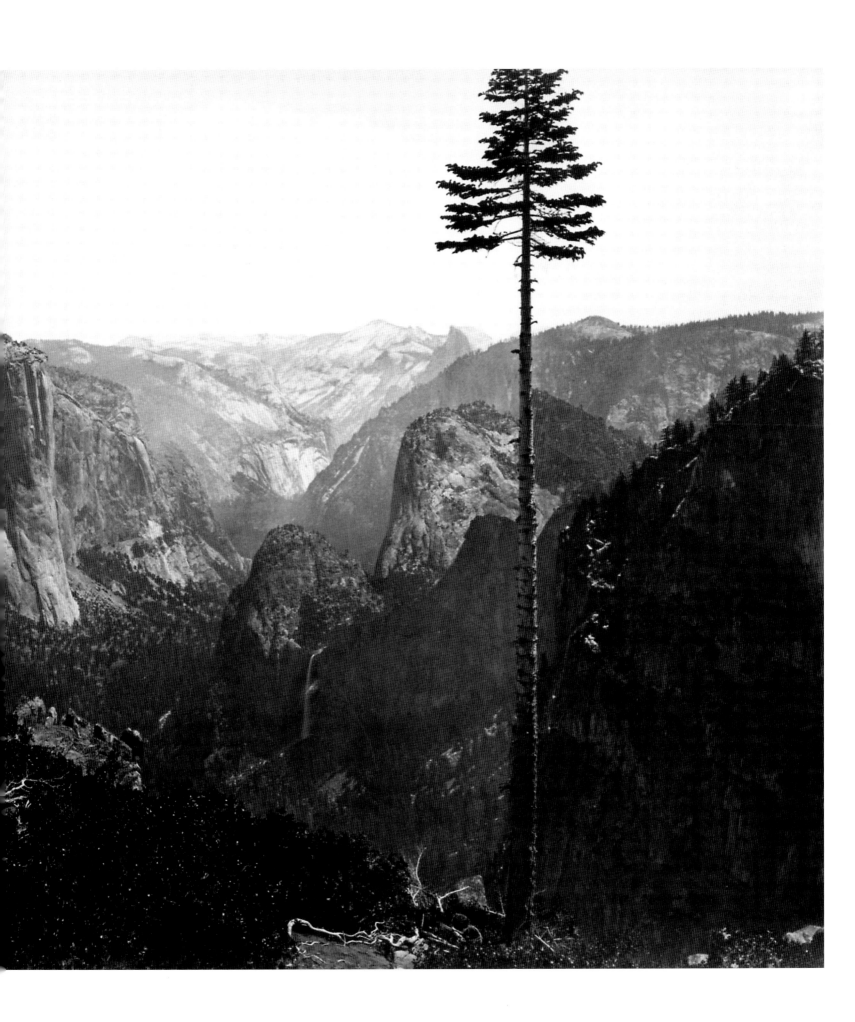

Andrew Joseph Russell

East and West Shaking Hands, Promontory Point, Utah May, 1869

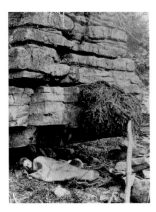

ANDREW JOSEPH RUSSELL

▪ 1830–1902

gained experience as a war photographer before accepting a Union Pacific commission to document the construction of the transcontinental railroad in 1865. The company published a beautifully illustrated volume of his photographs. In addition, a few shots taken around the track-laying work were published by the explorer Ferdinand Vandiveer Hayden in an album, *Sun Pictures of Rocky Mountains Scenery*, in 1870. At about this time Russell, who had also reported from the West as a journalist, returned to New York and opened a studio.

In the nineteenth century, no aesthetic refinement was necessary to present a steam locomotive as a symbol of advancement and progress, at least not in a setting as wild and impenetrable as the American West. Destruction of the wilderness and the social fabric by mechanisation was debated, but not for long. By the middle of the nineteenth century, the railroad had become a symbol of hope, both in the development and civilization of the wilderness and the democratization of the country.

In painting, this attitude led to a plethora of enthusiastic depictions of the westward quest. The photographs of the day, especially those recording the building of the transcontinental railroad, appeared sober and straightforward by comparison. Yet the images of new tracks extending arrow-straight to the far horizon of an empty prairie or desert could be read as symbols of superhuman effort—the geometry of the engineering art engendered a new form of sublimity.

The railroad companies hired photographers to record their feats of construction, such as tunnels, bridges, and tracks through the high Rocky Mountain passes. The photographs also served as advertisements for the West, helping to promote settlement. One such photographer was Andrew Joseph Russell, whose work was compiled by the Union Pacific Railroad Company in an 1869 volume called *The Great West Illustrated in a Series of Photographic Views Across the Continent Taken Along the Line of the Union Pacific Railroad, West from Omaha, Nebraska.*

Russell's most compelling picture was taken on May 10, 1869, when the tracks of the Union Railroad and the Pacific Railroad coming from opposite directions met at Promontory, Utah. In his journalistic snapshot of the celebrations, aptly titled *East and West Shaking Hands*, Russell produced a symbol of the beginning of a new era. F. L.

Andrew Joseph Russell,
*The Union Pacific Line
West of Cheyenne,
Granite Canyon, Wyoming,*
1869

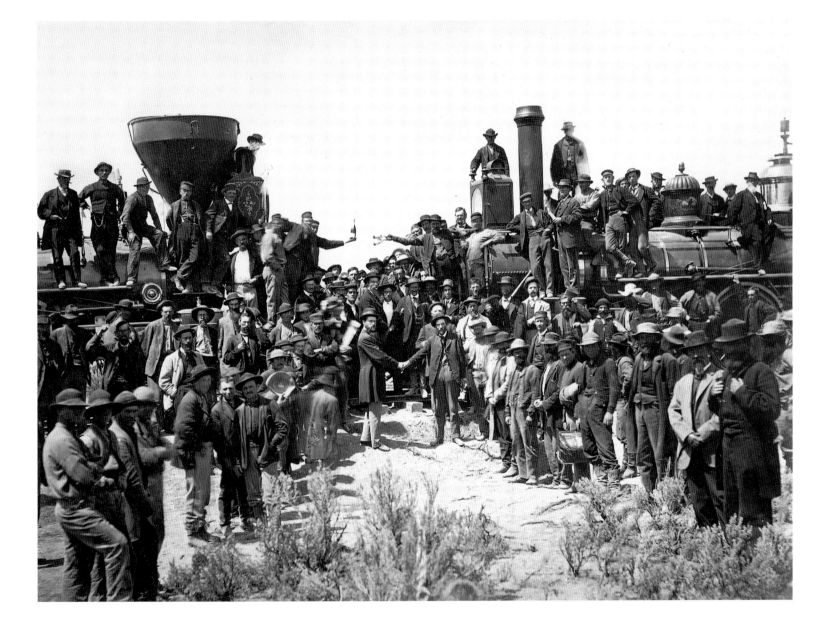

William Henry Jackson

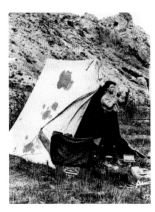

WILLIAM HENRY JACKSON
1843–1942

was a man of many talents—a painter
and writer as well as a photographer.
Raised on the East Coast, after the Civil
War he went West as a coachman. In
1868 he opened a photographic portrait
studio in Omaha, Nebraska, but soon
began to specialize in landscape pho-
tography. Jackson documented the
building of the transcontinental railroad
and the life of Native Americans. For
nine years he served as official photog-
rapher on government expeditions.
Around the turn of the century, Jackson
traveled the world for *Harper's Weekly*.
In 1940 he recounted the story of his life
in the book *Time Exposure*.

Until the middle of the nineteenth century, reports on the wonders of Yellowstone, its hot sulfur springs and stalagmite terraces, waterfalls, and geysers, were considered tall tales spread by a few bragging trappers. Few people believed the first scientific publication on the subject, which appeared in the late 1860s. So, on his expedition in summer 1871, Ferdinand Vendiveer Hayden, geologist and surveyor for the U.S. government, decided to take a photographer along—William Henry Jackson.

Hayden hoped that photographic evidence of Yellowstone's natural wonders would help him obtain funds for subsequent research trips. Jackson, on the other hand, whose Omaha photo-graphic studio was always on the verge of bankruptcy, saw his chance to become famous. In addition to simple documentary work for the report, he set out to create grandiose compositions, many of which he discussed in advance with Thomas Moran, the official expedition artist. In dramatic views Jackson infused his confrontations with the enchanted wilderness with a romantic yearning for the primeval. His photographs were instrumental in the January 1872 decision of the U.S. Congress to declare the Yellowstone region a national park—the first of its kind in the world. F. L.

William Henry Jackson, *The Mountain of the Holy Cross*, 1871

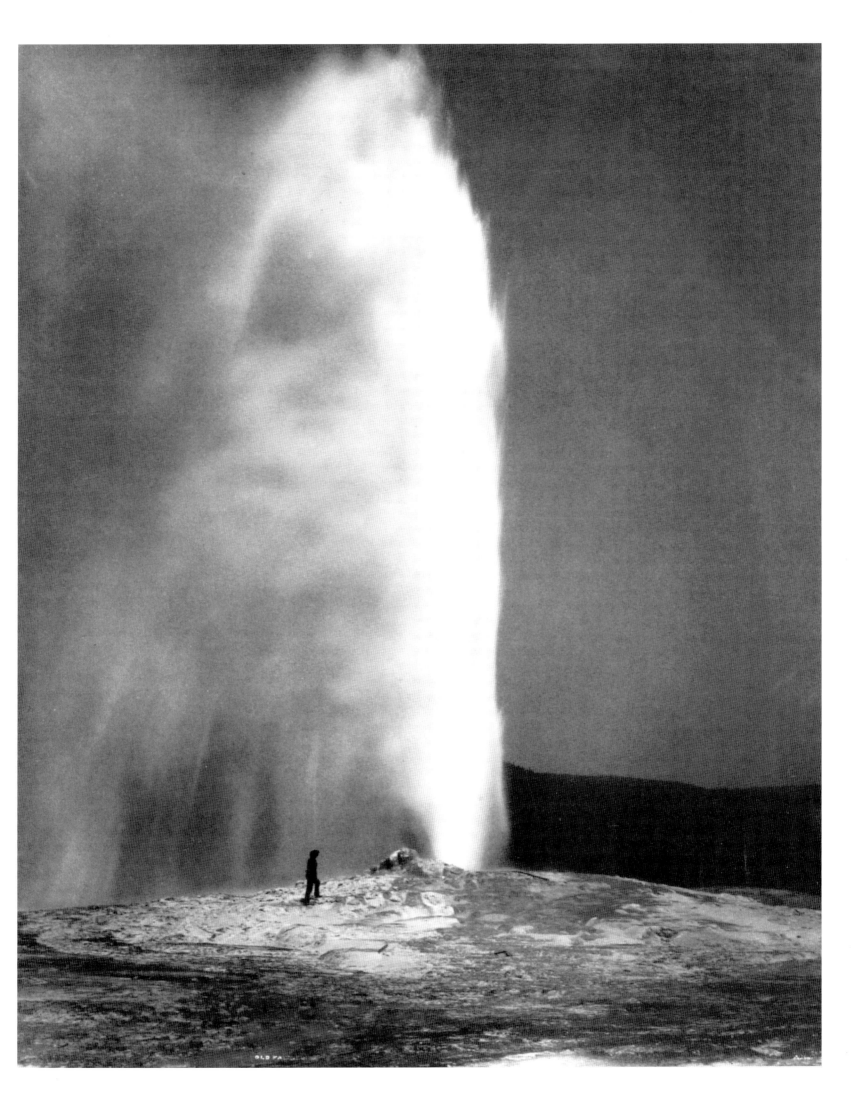

Charles Milton Bell

Perits-shinakpas (Medicine Crow) 1880

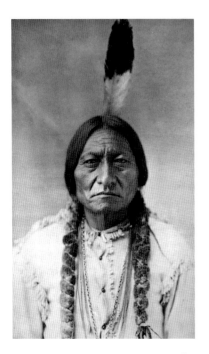

David F. Barry, *Tatonka e Yotanka (Sitting Bull)*, 1885

Photographs of Native Americans date back almost as far as the technique of photography itself. The images range from straightforward records to heroic apotheoses of the "noble savage" or "brave warrior." Influenced by the photographer's intentions and ideas, the photographs tend to reflect the conventional thinking of the era, and the models themselves did not have much say as to the way they were represented. The best-known photographs were not even taken in their native lands, but in Washington.

From the middle of the nineteenth century, the U.S. government repeatedly invited delegations of Native American chiefs to the capital to negotiate land deals and peace treaties. A visit to a photographic studio was nearly always on the agenda. While the earliest pictures still demonstrated an attempt to capture the sitters' individuality, from the 1870s onwards—when their personal rights had been considerably curtailed too—Native Americans tended to be looked upon as visual representatives of their tribes.

Charles Milton Bell was official photographer of the Department of the Interior and the Bureau of American Ethnology at that time. As a result, he focused more on precisely recording the clothing, jewelry, and possessions of his sitters than on capturing their unique personalities. Still, looking at the models today, their mask-like features and statuesque poses do convey a certain dignity.

A case in point is the war chief and medicine man of the Crow, Perits-shinakpas (Medicine Crow), photographed in 1880 at the age of thirty-two. Perits-shinakpas had made a name for himself as a warrior in battles against the Shoshone, Sioux, and Arapaho, before joining the American Army campaign against the Sioux and Nez Percé in the mid 1870s. F. L.

CHARLES MILTON BELL

▪ 1848–1893

was the youngest child of a family of photographers who lived in Washington, D.C. After working in the studio of his father and brothers, he established his own studio in 1873 on Pennsylvania Avenue. His work was a great success from the start, and his clientele soon included many of the capital's most prominent citizens. On recommendation from the geologist Ferdinand Vandiveer Hayden, Bell became official photographer of all the Native American delegations that came to Washington for government negotiations.

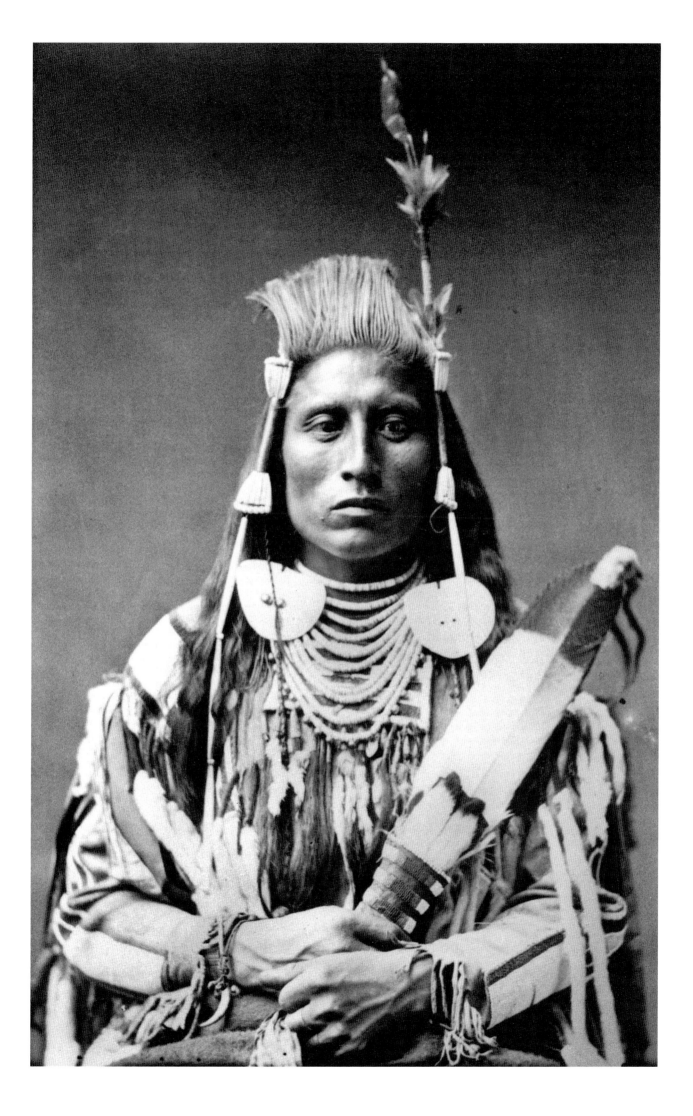

John Thomson

JOHN THOMSON
1837–1921

was born in Edinburgh and adopted the
profession of photography at an early
age. He moved to Singapore in 1862,
and made trips from there to India.
After selling his studio in Singapore, he
traveled through Siam (now Thailand),
Laos, and Cambodia, then settled in
1868 in Hong Kong, where he married
an English woman. Further travels
through Southeast Asia and especially
China followed before he returned to
London for good in 1872. Thomson
published numerous books, including
the photo reportage *Street Life in
London,* in 1878, which has a markedly
strong social element. In 1917 he was
named lifetime honorary member of
the Royal Geographic Society.

Still Life with Exotic Fruits *c.* 1868

Still life was a favorite subject with nineteenth-century photographers, as it was with painters. Yet the success of such pictures does not imply that they were treated like painted still lifes—framed and hung in living rooms. Normally still-life photographs served as reference material for other artists, such as painters, textile and wallpaper designers, book illustrators, sculptors, and interior decorators. They valued the precision of such photographs, and occasionally their pleasing composition. The fascinating thing about them is their authors' extraordinary sense of the painter's values. Even though the photographs may have been viewed merely as aesthetic raw material, they can hold their own in the eyes of posterity as autonomous works of still-life art.

John Thomson's still lifes offered the additional charm of the exotic. All the natural treasures of a distant, inaccessible land somewhere on the horizon of the great Commonweath seem gathered together here. They must have induced an array of feelings, from astonishment to curiosity or a yearning for distant lands to a pride in possessing them, in the audience at home in England. Although the beauty of the natural produce and the geometric composition may lend it a timeless look, this colonial still life speaks of the desires and vanities of an era. W. W.

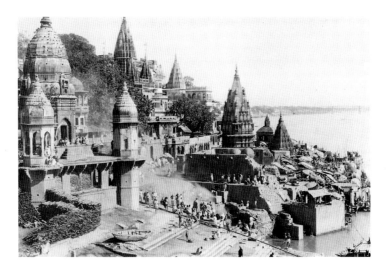

John Thomson, *The Banks of the Ganges in Benares,* 1870

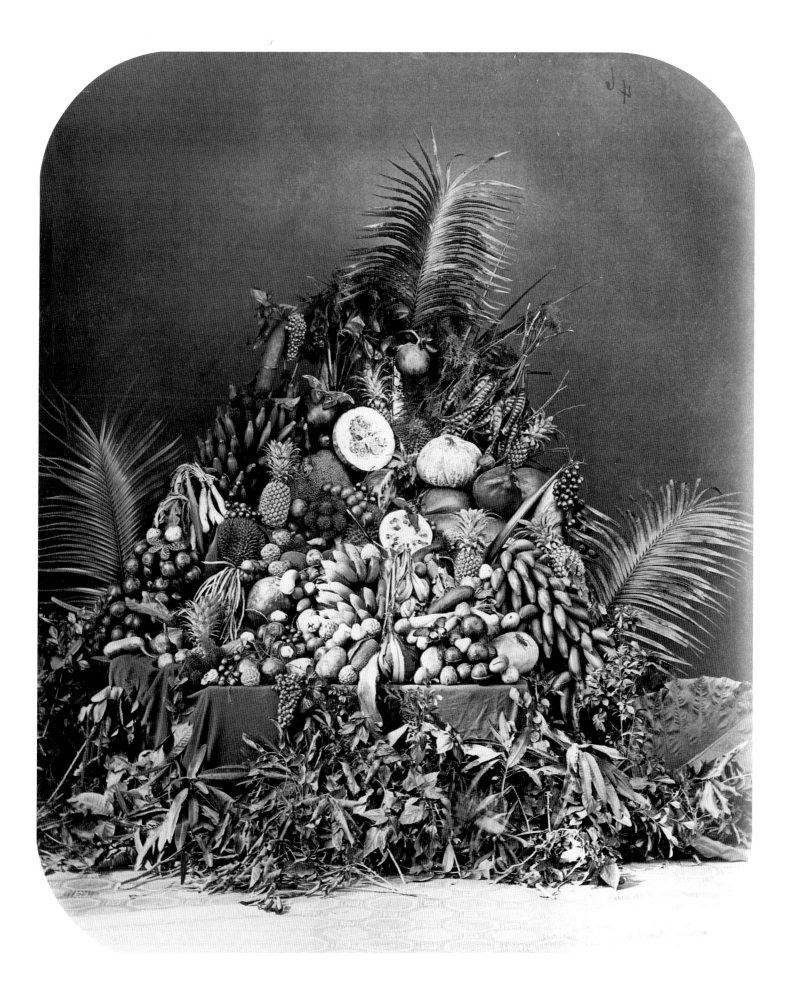

Samuel Bourne

SAMUEL BOURNE
1834–1912

was a bank employee and amateur photographer before leaving for India in 1863. In Simla in India, he became partner in the photographic studio of Charles Shepherd, whose architecture and landscape prints were sold to visitors and distributed in Europe. Despite the great success of his photographs, Bourne returned to England in 1872 and bought a cotton mill in the town of Nottingham. He became a textile manufacturer and hardly ever picked up his camera again.

New Road near Rogi, Himalayas 1866

When Great Britain was still a colonial power and India the favorite jewel in Queen Victoria's crown, every English visitor to the subcontinent must have felt like a conqueror. Samuel Bourne looked and acted the part. For seven years during the 1860s he took part in expeditions through India, Burma, Ceylon, and into the Himalayas, photographing for his company Bourne & Shepherd. And every time, a caravan was set in motion. Up to eighty servants carried provisions, photographic equipment, tents, furniture, a reference library and portable darkroom, and occasionally the photographer himself, in a sedan chair! Bourne was a fop who valued his comfort at all times, not only when staying in a maharaja's palace.

So, heavily equipped, he reached the source of the Ganges or set up his camera at the highest point of the over eighteen-thousand-foot-high Manirung Pass. "Photographic enthusiasm," he boldly informed readers of his serialized reports in *The British Journal of Photography*, "could not go much further than this." The installments of Bourne's travelogue published in the journal "filled amateur photographers with awe." He gave accounts of the hazards experienced in the cold and of his tirades against the native people, who posed stiffly for the camera, their arms pressed "like pokers" against their torsos and their chins raised, as if they expected the photographer "to cut their throats."

These were the obstacles to the make-believe atmosphere Bourne sought. His remedy was compelling. In his finest pictures, he placed the figures in the middle ground, with their backs turned. This was a compositional device borrowed from Romantic art. Yet his imagery by no means shared Romanticism's tendency to gloominess; in fact, quite the contrary. With their clear lines and subtle lighting effects, Bourne's prints are pervaded by a sense of harmony. His visions might have arisen straight from the pages of *The Arabian Nights*. F. L.

Samuel Bourne,
*The Maharaja of Rewah
and Retinue,* 1870

Felice Beato

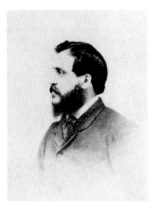

FELICE BEATO

c. 1820 – after 1904

Biographical details about Felice Beato are not very reliable. A cosmopolitan of Venetian descent, he set off in 1850 with the photographer James Robertson to explore the Mediterranean region and the Near East. He recorded the consequences of the Crimean War, traveled on to India and China, and landed in 1863 in Japan, where he spent about fifteen years. Beato opened a studio in Yokohama, the first ever established by a foreign photographer. In 1868 his two-volume work *Photographic Views of Japan with Historical and Descriptive Notes* was published. In the 1880s he traveled to England, Egypt, and Sudan. After that, his movements became increasingly difficult to follow.

Tattooed Stableboy *c.* 1865

Felice Beato's images of Japan record the final moments before the great cultural transition that took place there in the latter half of the nineteenth century, and, at the same time, they were a result of it. Beato was the first European permitted to explore the country with a camera. In the wake of diplomatic missions, he was also one of those foreigners who brought Western influences to Japan and accelerated its opening to the outside world. So it is still a matter of conjecture whether he did not actually create much of what he set out to discover.

Beato photographed people and scenes that struck him as typically Japanese—and he had no scruples about rigorously composing or arranging them. An avid collector, he was as interested in picturesque landscapes and cityscapes as in recording a cross-section of the Japanese population. Beato photographed representatives of an ancient, hierarchical society in decline, not only in inaccessible villages and rural areas. He also arranged his subjects in theatrical poses against a neutral studio background: sumo wrestlers and samurai; a government official and geishas; a messenger demonstrating how fast he could walk; the tattooed back of a stableboy.

Unique examples of an exotic world, these people seem strangely devoid of individual traits. Even when a fear of the photographer is clearly evident from their faces, we do not feel Beato has given much insight into their personal lives. Even here, as so often in this type of photography, human beings become symbols, perhaps of the shock triggered by the incursion of an alien world into their own.

F. L.

Felice Beato,
Women Sleeping, c. 1865

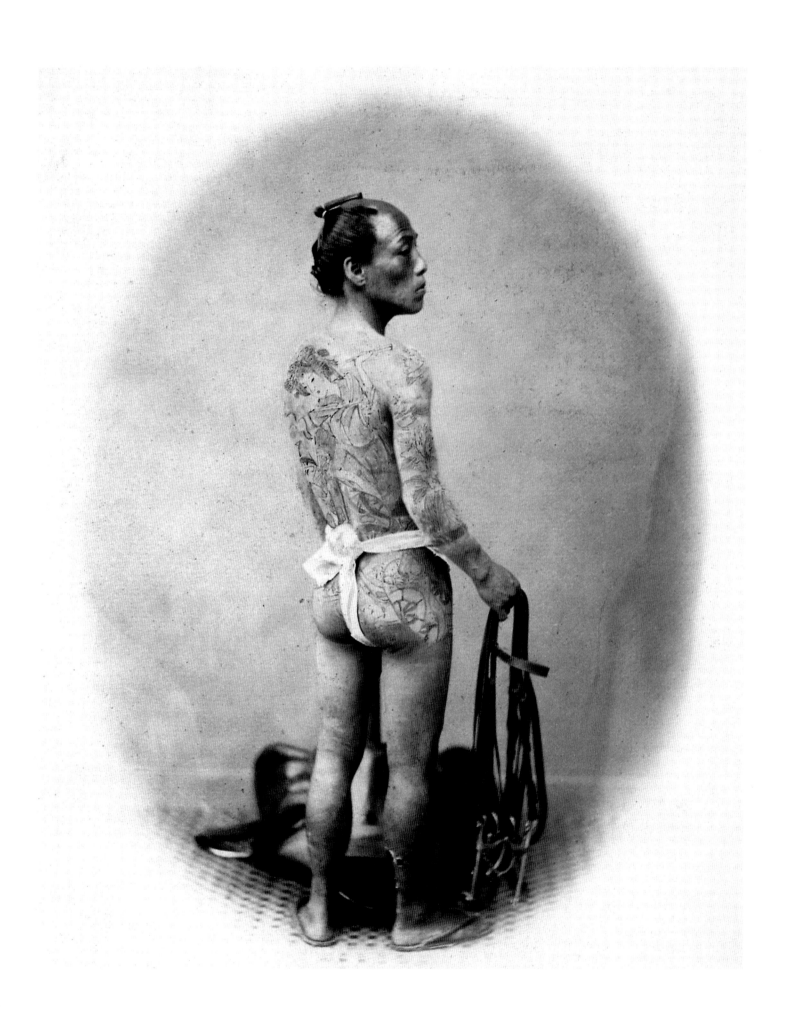

John L. Dunmore &
George Critcherson

Icebergs in Baffin's Bay 1869

"... no one before him had photographed so far north," wrote John L. Dunmore after his return from the Arctic. This quotation has the ring of adventure, conjuring up images of a daring expedition into the icebound realm north of the Arctic Circle. Actually the voyage with the ship *Panther* up the Davis Strait into Melville Bay between Greenland and Baffin Island seems to have been more of a pleasure cruise than an expedition. It had been organized in the summer of 1869 by William Bradford, an American landscape painter who wanted "to study nature," as he put it, "under the terrifying aspects of the Frigid Zone." In addition to various amateur artists, Bradford invited two photographers—John L. Dunmore and George Critcherson—from James Wallace Black's studio in Boston with a view to using their pictures as the basis for paintings. Yet the photographs they brought home, many on 14 × 18 inch glass plates, turned out to be far more than mere sketches. For his book *The Arctic Region*, published in 1873, Bradford selected one hundred and thirty-nine images that were put into the album as original prints.

John L. Dunmore & George Critcherson, *in Melville Bay*, 1869

Dunmore and Critcherson are known today solely on the basis of these photographs, little of their other work having survived. Initially Dunmore was not captivated by the Arctic landscape, seeing "nothing alive there, only rocks and icebergs," as he reported in a letter to the editor of a Philadelphia photographic journal. The working conditions did not appeal to him either. The multiple light reflections from ice and snow, he complained, "had robbed his pictures of depth." But it was false modesty. Dunmore and Critcherson showed the Arctic as a place of beauty and sublimity, where excitement is tempered by fear. Human beings, often no more than dots against the background of mighty icebergs, seem utterly absorbed by the white expanse, and the ship appears on the verge of being crushed by pack ice. Even the proud poses of the men displaying their hunting trophies—three polar bears—have an air of bravado. F. L.

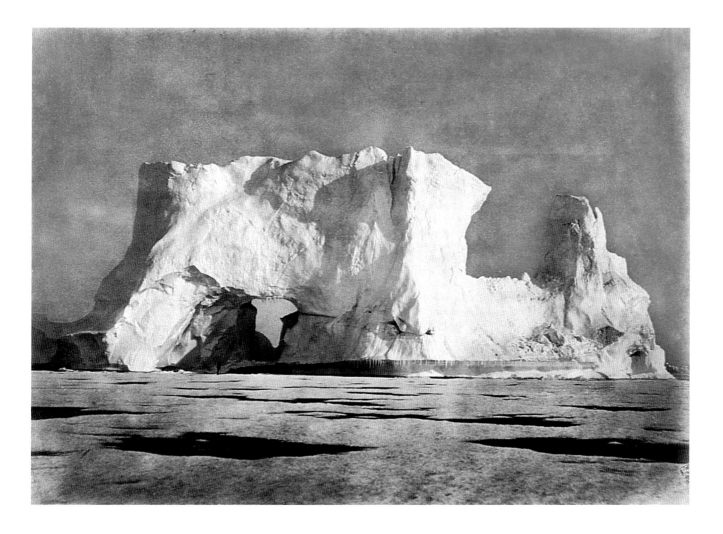

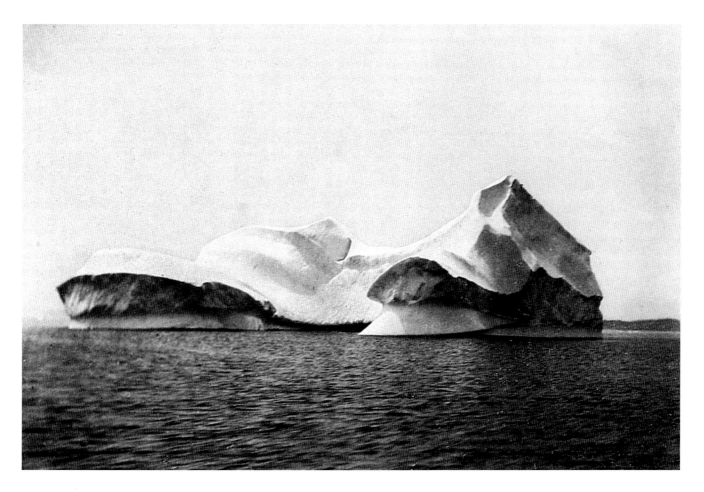

Félix Bonfils

Tourists Climbing the Pyramid of Cheops in Giza *c.* 1870

Félix Bonfils, *Coupole de Douris, Baalbek, c.* 1870

FÉLIX BONFILS

1831–1885

was a printer in the southern French
town of Alès before moving in 1867
to Beirut, where he opened a photo-
graphic studio. In 1878 his son, Adrien,
took over the studio and converted
it entirely to mass production.

"Those who are prevented from traveling to these sites due to illness, lack of funds, or their domestic situation," wrote Félix Bonfils in the introduction to his 1878 photograph album *Egypt and Nubia*, "have the possibility to go at their leisure, at low cost and with little effort, to those countries which many have reached only at the risk of their lives."

Bonfils had moved from France to Beirut in 1867, opened a studio, and traveled extensively through the Middle East taking photographs. Bonfils profited from the enormous popularity of Egypt as a result of organized tours that had been introduced in the latter half of the nineteenth century.

With an eye to sales, Bonfils rarely looked for unconventional views. He was one of many travel photographers of the period whose compelling if conventional compositions established the supposedly ideal vantage points on countless historical sites.

In the case of the pyramids of Giza, two such vantage points were rapidly found. First, an overall view from a distance with the Sphinx in the foreground (whose progressive excavation in the course of the decades facilitates the dating of early photographs), and second, a close-up view of a lower section of the pyramid. People looking at the photographs could immediately identify the monument based solely on this diagonal edge.

The image's anecdotal character, however, was even more important. Bonfils' view clearly emphasized the group of local guides and tourists clambering up the pyramid, which made it a perfect souvenir. It was not only those who stayed home but above all travelers who bought pictures like this. They were mementos of the highlights of their Grand Tour and proof to their friends and relatives of how strenuous and exciting the trip had been. F. L.

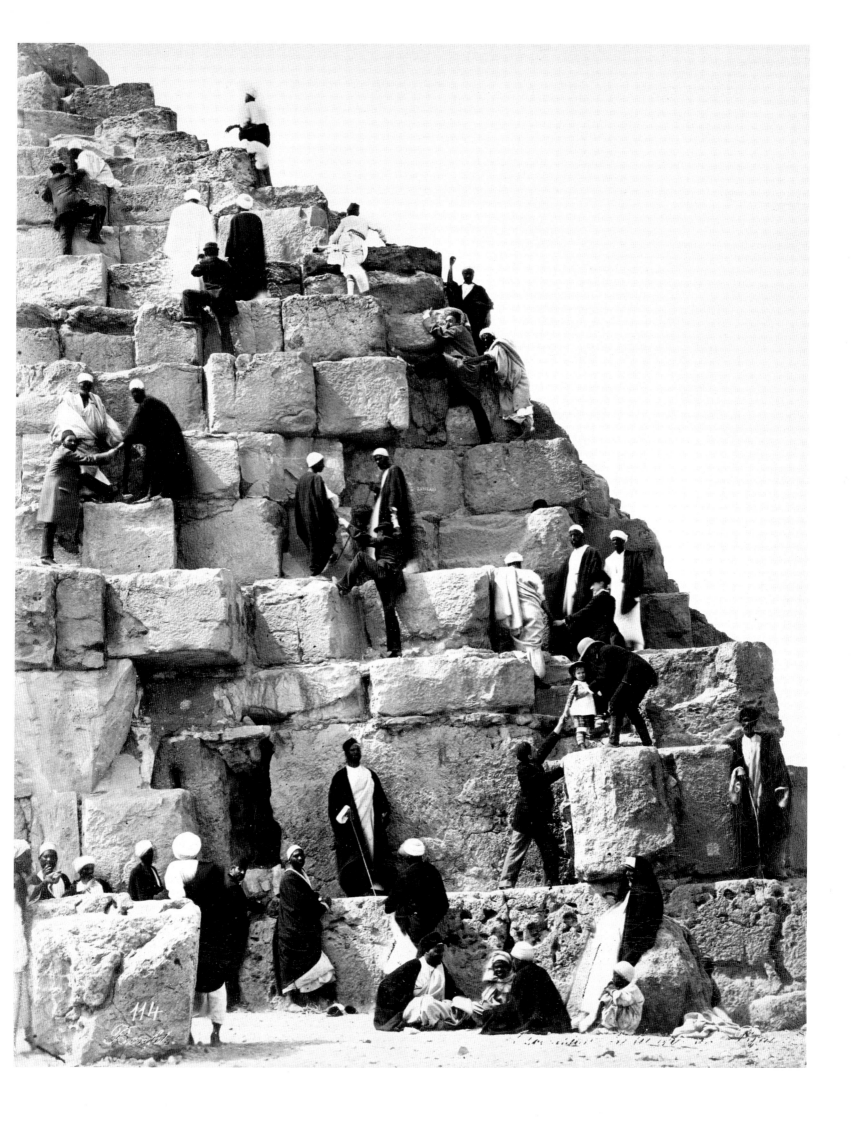

Adolphe Eugène Disdéri

Dead after the Uprising of the Commune 1871

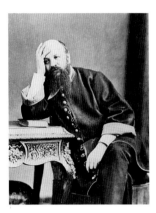

ADOLPHE EUGÈNE DISDÉRI
▪ 1819–1889

was born in Brest in France, where he
worked as a daguerreotypist before
moving to Nîmes in 1853. After a time
in Paris, he finally settled in Nice in the
1870s. It was probably he who invented
the *carte de visite* format, which re-
mained the most popular portrait
format until World War I. Like stereo-
photography, the visiting card photo-
graph was one of those commercially
successful fads that heralded the start
of photographic mass production.
Disdéri authored a detailed discussion
of the medium called *Photography as
a Visual Art*, 1862.

The uprising of the Commune of Paris in 1871 was one of the few political events in the nineteenth century to have been photographically documented from beginning to end. Many Parisian photographers were working in the city, recording the building of barricades, the stockpiling of weapons, the demolition of the Vendôme Column, and the valiance of the rebels. After the rebellion was crushed by national troops, the ruins of prominent buildings torched by the Communards became a favorite subject. A new market for macabre photographic souvenirs was established.

One of the grisliest pictures of the days immediately following the rising shows the corpses of twelve rebels lying fully clothed in their open coffins. From their appearance, it is difficult to say whether they were killed in action or—as is more probable—were among the thousands who faced a firing squad after the barricade fighting was over. Two have suffered such devastating head wounds that they had to be concealed by bandages. On each body lies a sign with a number, probably to assist relatives to identify their loved ones even after burial. The practicality of this bureaucratic numbering of nameless men highlights the irreverence of this sort of display. W. W.

Anonymous,
*The Destroyed City
Hall of Paris,* 1871

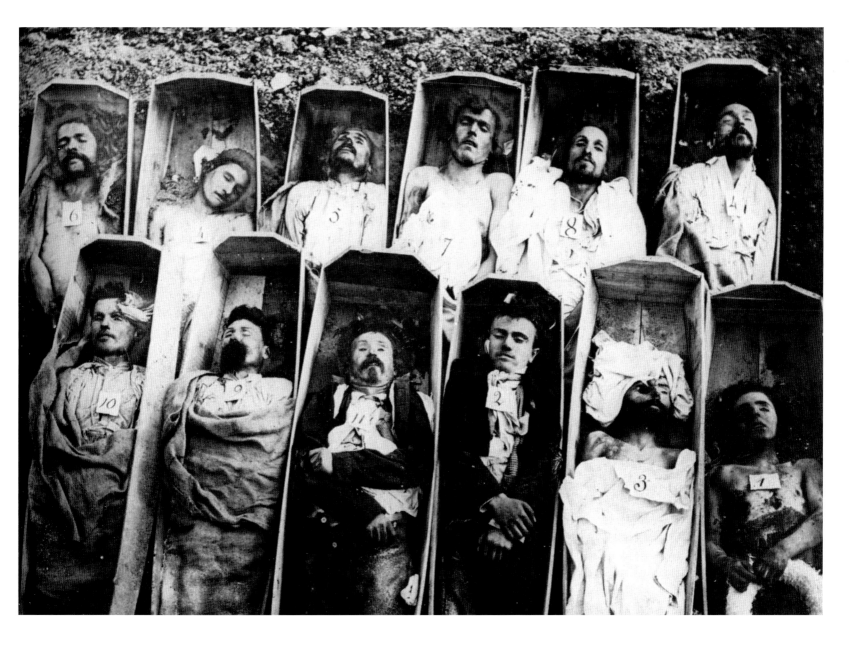

Giorgio Sommer

Eruption of Mt. Vesuvius 1872

GIORGIO SOMMER
1834–1914

was born in Frankfurt am Main, Germany. It is said that he took up photography as a profession after his father had gambled away the family fortune in a single night. In the mid-1850s he worked successfully in Rome for several years, then settled in Naples. He became one of southern Italy's leading photographers. Sommer specialized in the documentation of tourist attractions, such as the archeological digs in Pompeii and Herculaneum.

Nineteenth-century photographers very rarely had the opportunity to witness a spectacular natural occurrence. Giorgio Sommer's report on the eruption of Mt. Vesuvius in 1872 was one of the great exceptions. The photograph was apparently taken from a boat, from a distance that permitted a panoramic view including the city of Naples, the volcano, and the plume of smoke. A comparison with the cowering city gives an idea of the threatening dimensions of the cloud of ash; yet the visual impact of the image is due to the vantage point from the boat. The photographer's position is like that of a refugee who has escaped the terrible calamity and glances over his shoulder one last time at his seemingly doomed home town.

The 1872 eruption was indeed disastrous. In addition to widespread destruction, many lives were lost. Sommer took several similar pictures that same day, sometimes at intervals of less than half an hour, and marked them with the precise time. They all record the enormity of the cloud billowing into the sky, but they also convey the imposing grandeur of such natural spectacles. W. W.

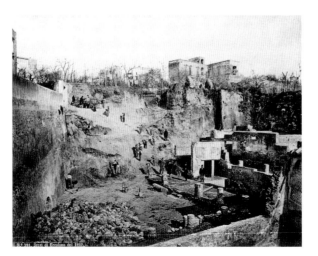

Giorgio Sommer, *Archaeological Excavations in Herculaneum*, 1869

90

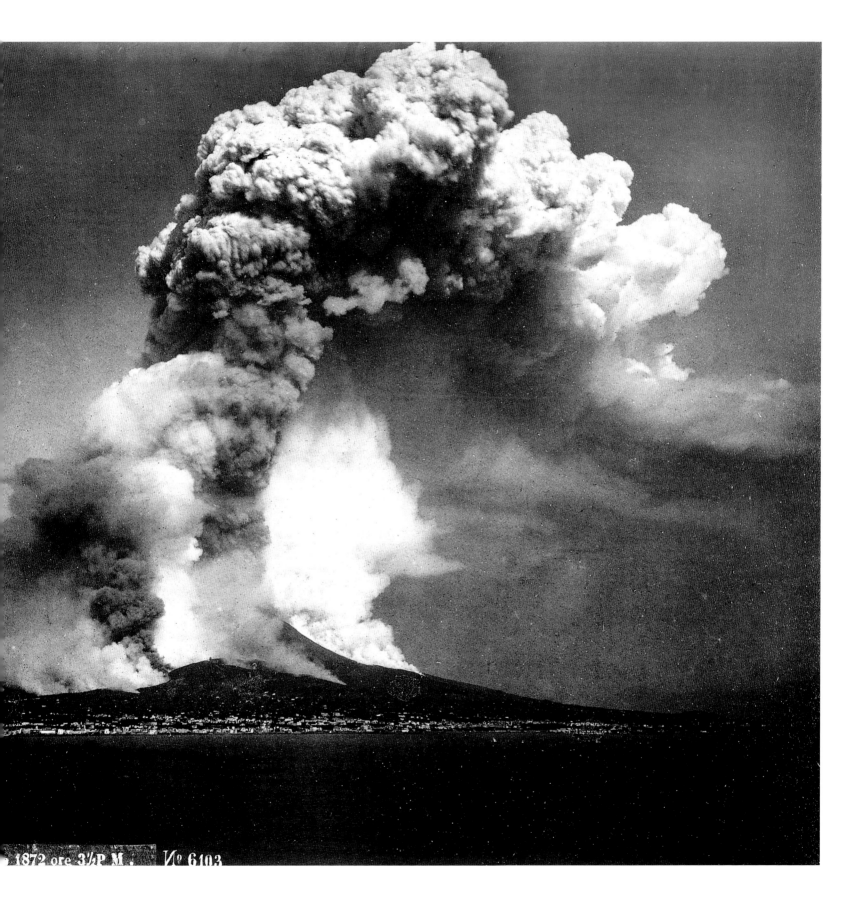

1872 ore 3½ P. M. N° 6103

Carlo Naya

Two inventions altered the nineteenth-century view of distant places—the railroad and photography. Continually expanding transportation networks permitted travelers to visit destinations they had previously known only from written accounts. Travel guides pointed out interesting buildings and landmarks, and photographs were often available as souvenirs. Greater mobility expanded people's horizons, yet at the same time limited them, because most people were satisfied with pictures of only the best-known sights.

Venice was a favorite destination of Mediterranean travelers. The city's many canals—over one hundred and fifty of them—made it remarkable, and its checkered history lent it an air of mystery. This was reflected especially in the Ponte dei Sospiri, or Bridge of Sighs, erected around 1600 to connect the Palazzo Ducale and its notorious "leaden chambers," whose inmates had included Casanova, with the new state prison. Nearly every picture of the bridge taken by local and visiting photographers was from practically the same vantage point, with the result that their prints often differed only in terms of the number of boats on the water. Carlo Naya was one of the few photographers who pictured it from the opposite side, thus challenging the stereotypical tourist view. T. S.

Jakob August Lorenz, *View of S. Maria della Salute from the Molo,* Venice, 1853

CARLO NAYA

■ 1816–1882

after studying law in Pisa, traveled widely before settling in Venice in 1857. Initially he was an amateur photographer and he worked with Carlo Ponti, who distributed his prints. After quarreling with Ponti, he opened a separate studio in 1868. Like his partner, he was one of those photographic chroniclers whose prints provided a comprehensive repertoire of the city's sights— buildings and monuments, harbor views and panoramas, restoration work and frescoes by Giotto, street vendors and passersby in typical local costume.

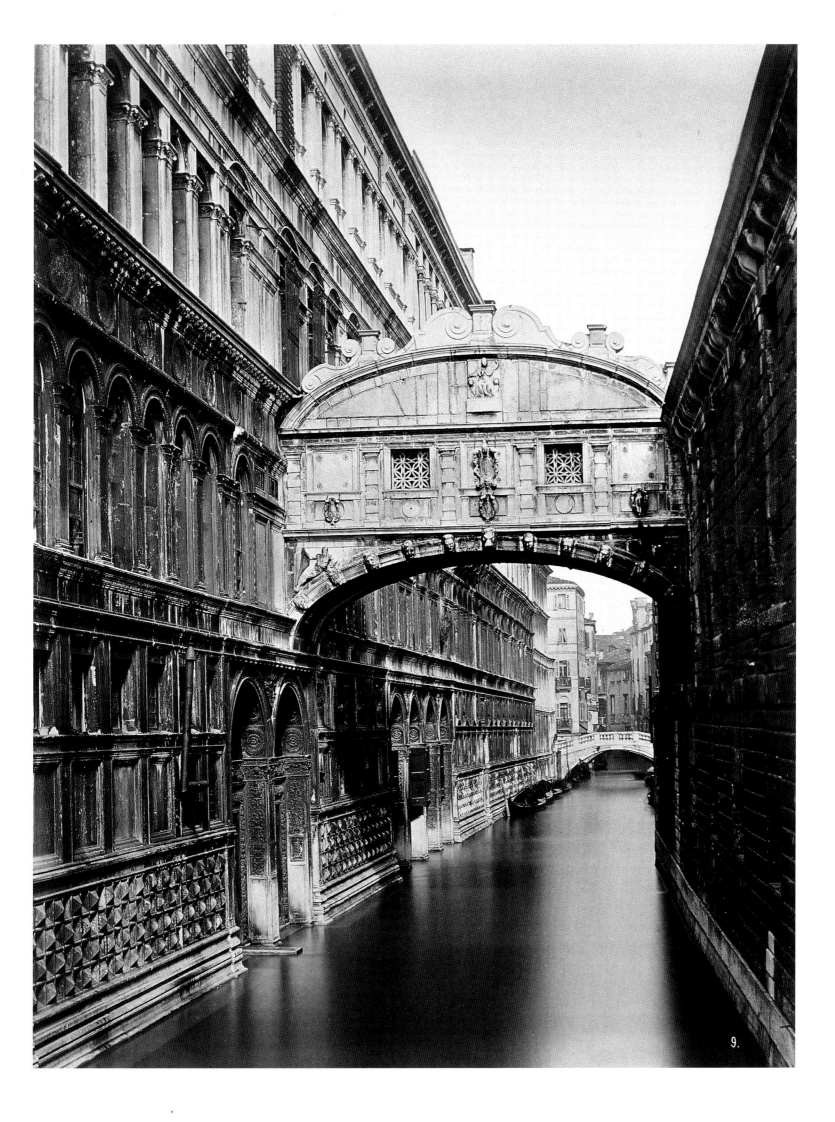

9.

The Alinari Brothers

LEOPOLDO ALINARI
1832–1865

ROMUALDO ALINARI
1830–1891

GIUSEPPE ALINARI
1836–1891

Fratelli Alinari (The Alinari Brothers)
was the name of the company jointly
established in Florence in 1854 by
photographer Leopoldo Alinari and
his brothers Romualdo and Giuseppe.
They specialized in photographic repro-
ductions of works of art and views
of famous Italian architectural monu-
ments. The family enterprise was one
of the most successful photographic
firms of the nineteenth century and still
exists today as a publishing house.

View from Torre di Arnolfo, Palazzo Vecchio to Florence Cathedral c. 1895

In photographs of architectural subjects, precision was the first priority. Yet many such precise historical views contain distortions in perspective that seem almost absurd to a modern eye. That this effect was intentional on the photographer's part would seem unlikely. Although this picture of Florence shows a favorite tourist view from the city hall to the cathedral, its vantage point already departs from the norm in that it gives much more importance to the outlook platform than to the city itself. Florence seems merely a pretext to acquaint the viewer with the bizarre spiral staircase, which may have just been installed, thus encouraging the photographer to show it out of a sense of civic pride. At any rate, this is one possible explanation for the idiosyncratic composition.

Since the modest steel structure does not arouse much admiration in us today, our eye is free to appreciate the surrealist effect of the image. We cannot see where the stairs begin or end, and they seem to vanish into thin air on both sides of the pillar. The man with the hat appears to hesitate in his stride, probably at the behest of the photographer. The bright background light behind him turns him into a silhouette with few distinguishing features, almost as if he were a mannequin. How long is he going to stand there before finally being allowed to take the next step? W. W.

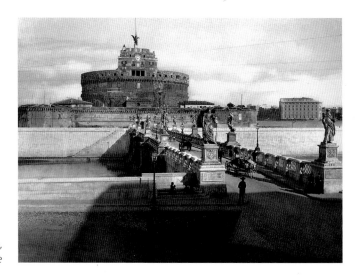

The Alinari Brothers,
Bridge and Castle of Sant'Angelo, Rome

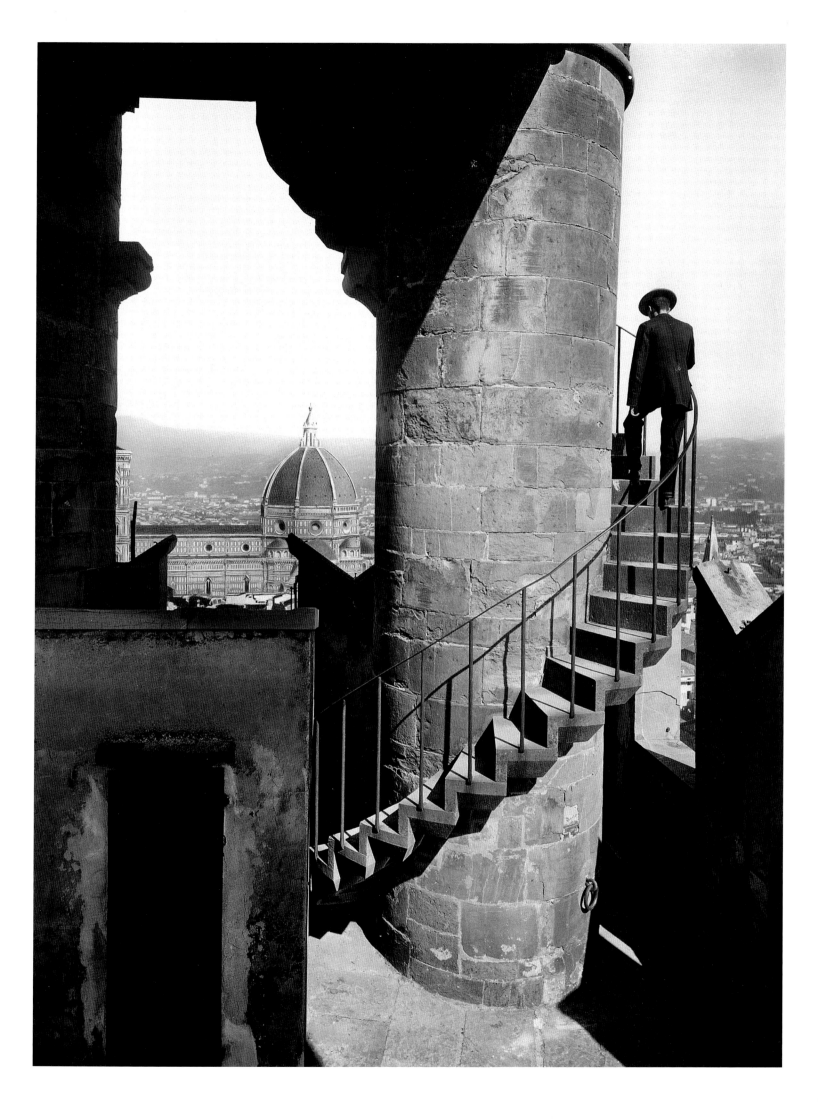

Peter Henry Emerson

PETER HENRY EMERSON

1856–1936

was born in Cuba. He went to England in 1869, completed a course in medicine, was a versatile author, and became an enthusiastic amateur photographer in 1882. In 1886 he held a lecture on the new art photography and gave up his career as a doctor. A series of his photography books appeared, the last in 1899. Emerson popularized platinum paper with its rich nuances and the reproduction technique of photo engraving. In 1892 he declared that photography was a purely mechanical artistic method. After a retrospective in London in 1900, Emerson's work was long forgotten.

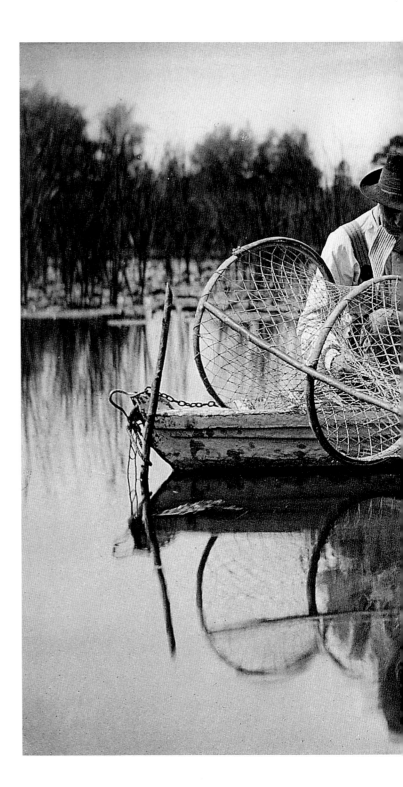

Setting the Bow-Net

1886

That photographs show life "as it is" was only partially true by the 1870s. It had become common practice among portrait photographers to use accessories and painted backgrounds, and devices such as montage, retouching, and over-painting were not rare. An ambitious type of art photography that enjoyed great popularity in England went even further. By theatrically arranging costume scenes and combining several negatives to make a single print, it attempted to emulate the works of history painters. But just as artists of the young generation in France had mounted resistance to the artificial compositions of the academies, young English photographers protested against this posed art photography. The spokesman of this movement was Peter Henry Emerson. He demanded a return to subjects from the everyday lives of the working population.

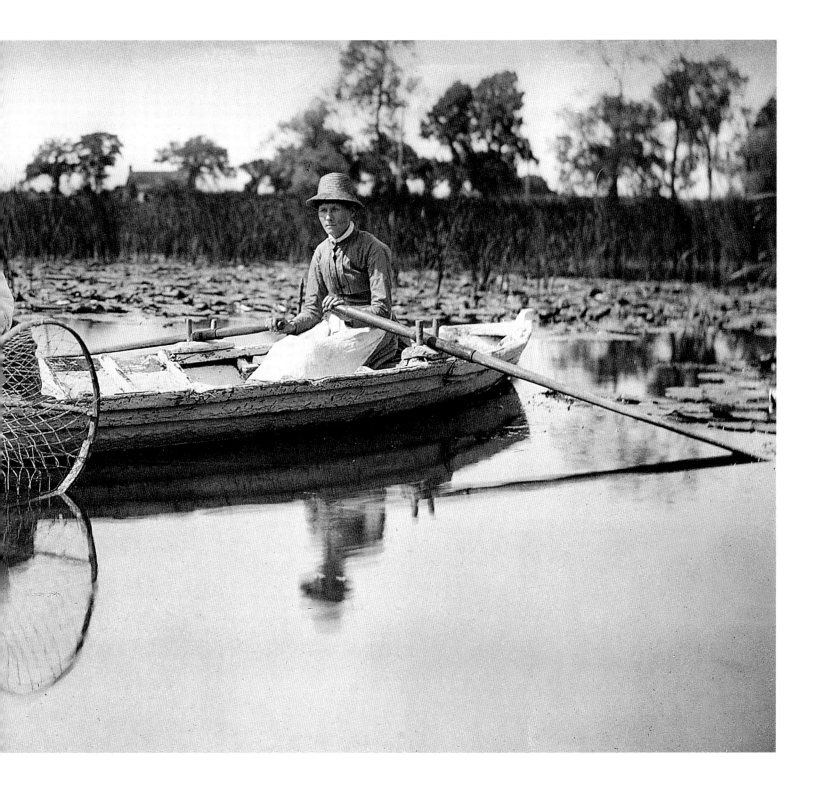

He also advocated a realistic method of picture taking. Like the human eye, the camera was to show only the main subject in focus and leave the rest blurred. His pictures of rural people in the English region of the Norfolk Broads are examples of this belief.

Although Emerson later renounced his theories, believing that only painting was capable of conveying artistic truth, the impulse he had triggered could no longer be stopped. In many countries art photography movements emerged which experimented with the stylistic device of conscious lack of focus.

W. W.

Frank Meadow Sutcliffe

Waterrats 1886

FRANK MEADOW SUTCLIFFE
1853–1941

son of an artist in Leeds, England, began
to photograph at the age of fifteen and
in 1870 moved with his parents to the
harbor town of Whitby. After unsuccess-
fully attempting to establish himself
as a portrait photographer in another
town, he returned to Whitby, where he
prospered thanks to increasing tourism.
His beautifully composed harbor scenes
made the town famous. Sutcliffe's
career ended in World War I, when
taking photographs of the coast zone
was prohibited.

Although the fresco Michelangelo planned for Florence city hall, *The Battle of Cascina,* was never painted, copies of the preliminary drawing did survive, including an engraving of *Soldiers Bathing.* It shows men, naked or half-undressed, in various poses on the bank of a river. For centuries this engraving served as a model for nude accessory figures, which were long tolerated only in landscape paintings. It was not until the nineteenth century that Realist artists began to treat male figures as subjects in their own right, they soon began to favor adolescents and children over adults.

Photographers too adopted this popular theme. While artists such as the American, Thomas Eakins, used his photographs of men swimming in the nude as preliminary studies for paintings, the photographer Frank Meadow Sutcliffe viewed his *Waterrats* as an autonomous photographic work of art. The picture was taken in Whitby harbor. One hot morning Sutcliffe noticed three nude boys swimming there and offered them money if they would wait until he came back with his camera. But his offer, as he reports, had gotten around, and when he returned he found thirteen boys. In order to arrange them as a group, he asked them to go fetch an empty boat. Once he was satisfied with the result, Sutcliffe's most important task was to prevent the boys from looking into the camera.

The picture was shown at a London photographic exhibition in 1886, and was much ac-claimed. It rapidly became his most popular work. W. W.

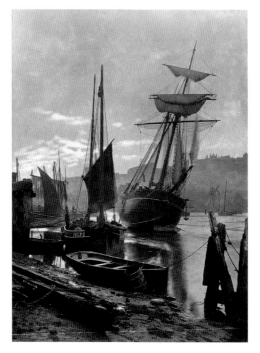

Frank Meadow Sutcliffe,
Morning, Whitby,
c. 1885

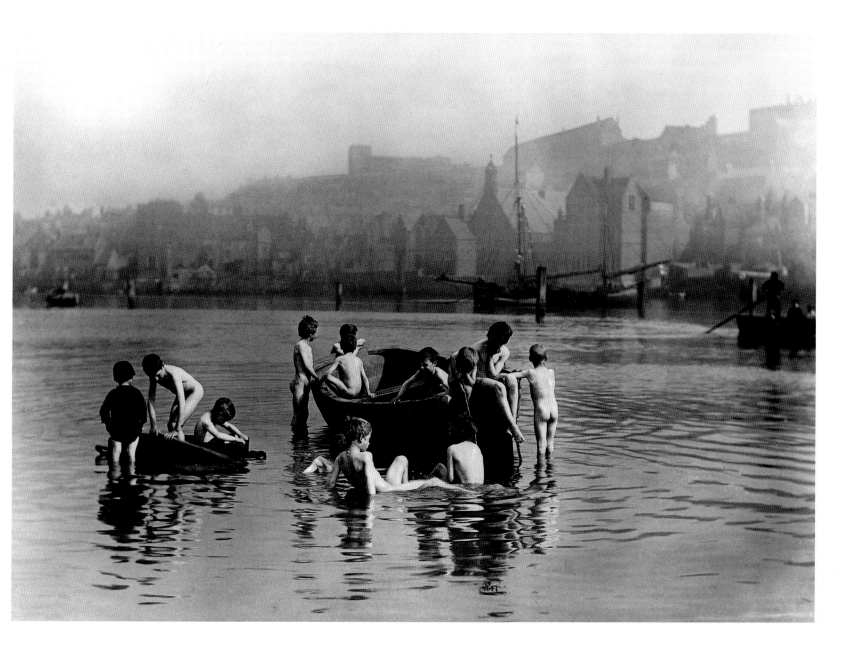

Jacob A. Riis

Bandits' Roost, 59 ½ Mulberry Street *c.* 1888

JACOB AUGUST RIIS
▪ 1849–1914

saw himself not as a photographer but as a social reformer who made use of the potential of the medium. Committed to improving the living and working conditions of immigrants in the slums, he encouraged the building of homes, parks, and playgrounds. In addition to his major work, *How the Other Half Lives,* he published a good dozen further books, almost all of them contributions to the reform movement. His autobiography, *The Making of an American,* was published in 1901.

Jacob A. Riis knew his subject intimately. He was one of fifteen children and lived in extreme poverty as a child. After emigrating to America from Denmark in 1870, he became a journalist, first with *The Tribune* in 1877 and later with the *New York Sun.* As their crime reporter, he often found himself in the city's slums. Finding words inadequate to describe the horrific conditions he witnessed, Riis took up photography and began experimenting with flash powder. He made no artistic claims for his work, especially as his prints had to be redrawn for publication in newspapers.

It was not until his first book, *How the Other Half Lives,* appeared in 1890, that autotype—an early photographic printing process—was employed for the illustrations. The book was a visual chronicle of a world removed from the public eye; the world of exploited immigrants who lived in damp basements, dark alleys, or on the street. Riis's graphic record has lost none of its impact even today.

We see people sleeping in a gloomy shed, or creeping into a cellar with nothing but boards for beds. The camera's flash literally catapults them out of obscurity and into the light of public awareness. Repelled by the idealized approach of the picturesque genre, Riis adopted a merciless viewpoint as the only adequate response to the harsh conditions he saw—and complained about—slum children who all too gladly lined up in front of his camera in "the most striking pose." F. L.

Jacob A. Riis,
*Ancient Lodger at Eldridge
Street Police Station, c.* 1890

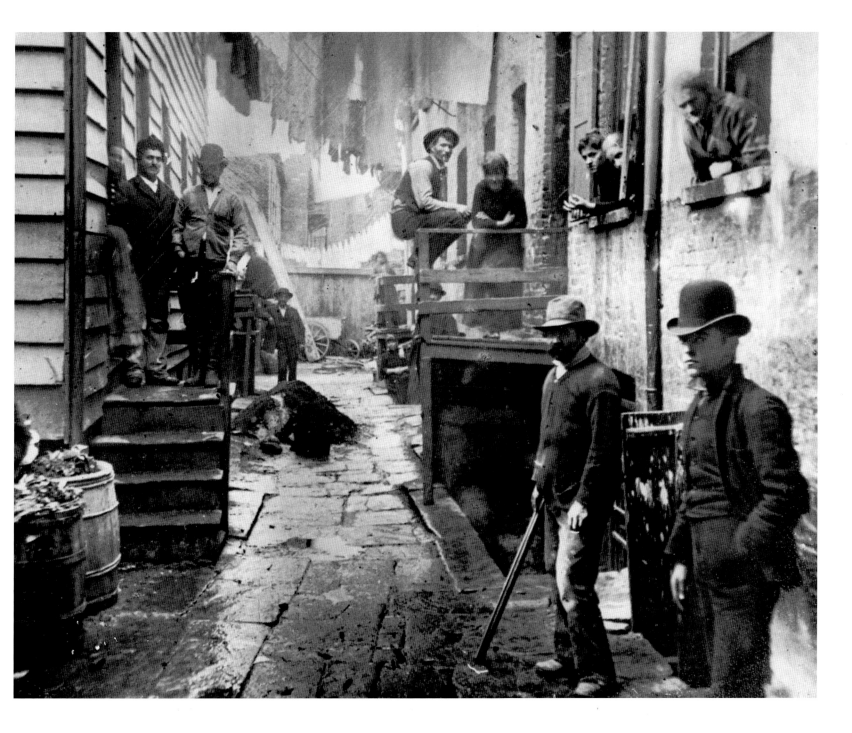

Eadweard Muybridge

Abe Edgington driven by C. Marvin 1885

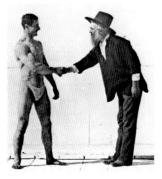

EADWEARD MUYBRIDGE
◼ 1830–1904

emigrated from England to California
and worked as a bookseller before
turning to photography in 1860. Initially
active as a landscape photographer,
he built equipment and projectors
for the production and presentation of
chrono-photographs. He demonstrated
his inventions on tours throughout
the U. S. and Europe and inspired many
others to make similar experiments.
Muybridge's studies of movement
appeared in the work *Human and
Animal Locomotion*, published in
several volumes.

In the course of the nineteenth century, photography was able to penetrate into and visually record the most distant nooks and crannies of the planet and beyond, yet it was virtually helpless in face of processes in time. Pictures of moving objects were either blurred or frozen in a state never truly experienced—that of stasis. Photographers and scientists had struggled with this drawback ever since the invention of photography, and they had found various ways to overcome it. Thanks to a reduction in exposure times, sharp-focus images became possible, and sequences of exposures gave an idea of the transformation of motifs and produced an appearance of motion. Yet the intervals between exposures were still too long, and parts of the phases of movement remained invisible.

It was not until the railroad millionaire and racehorse owner Leland Stanford decided to record horses' gaits, to establish whether a horse ever has all four hooves off the ground at the same time when galloping, that such phenomena were more closely explored. Eadweard Muybridge set up cameras in twelve cabinets, and connected their shutters with thread. The shutters were triggered when a passing animal broke the threads. In 1878, twelve sequential images of a galloping horse were taken in less than half a second. These chrono-photographs were then projected in rapid sequence using an apparatus developed specially for the purpose. The resulting impression was similar to that of cinema, where the jerkiness of the movements was overcome by projecting a greater number of individual images within a shorter time period. Muybridge also sold his sequences of photographs of people and animals as large format pictures. These met with great interest especially from artists and sculptors.

T. S.

Eadweard Muybridge, from *Human and Animal Locomotion,* 1887

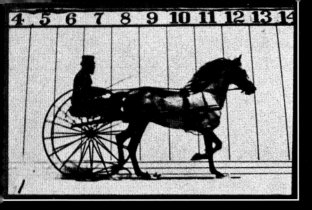

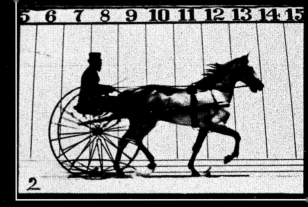

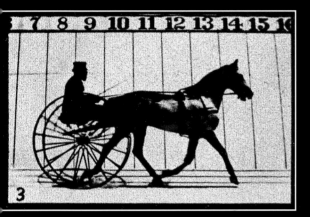

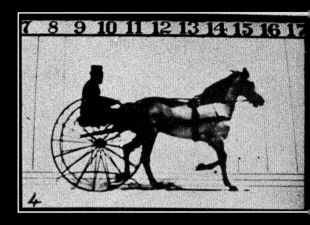

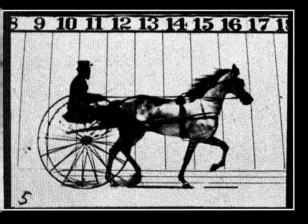

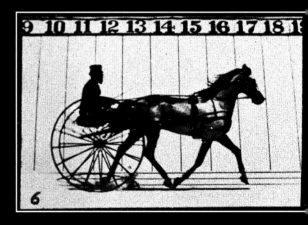

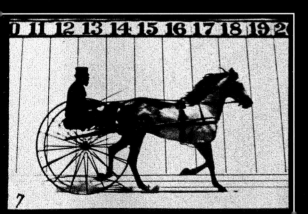

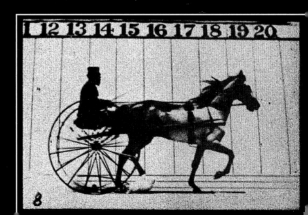

Ottomar Anschütz

Storks 1884

OTTOMAR ANSCHÜTZ
■ 1846–1907

trained as a portrait photographer.
When he took over his father's
photograph shop in Lissa, Posen,
he worked on improving the cameras
in his spare time. His invention of
the slit shutter, patented in 1888, made
instantaneous photography possible,
and its automated version, the
tachyscope, paved the way for motion
pictures.

Ottomar Anschütz was not an artist but an inventor. And he viewed the masterpieces he created as examples of technological advance—attractions on the basis of which he hoped to build an entertainment empire. As an entrepreneur, however, he was not a success.

His *Schnellseher* (literally, "rapid viewer," or tachyscope), a drum lined with sequential pictures that produced an impression of motion when rotated, proved commercially unsuccessful, and in 1895, production and development were discontinued. By the time true motion pictures appeared on the scene a short time later, Anschütz had long turned to the more contemplative field of portrait and landscape photography although speed had once been his greatest obsession. Anschütz had always wanted a camera fast enough to record split-second movements invisible to the naked eye.

In the early 1880s he designed a roller-blind shutter of his own invention for his hand-held camera that permitted exposure times of 1/1000th of a second. He tested this invention during maneuvers of the Imperial Cavalry, where he set out to capture the interweaving ranks of horses and riders. Later he focused his camera on children at play and athletes throwing the javelin.

Anschütz's sequences of storks taking off and in full flight caused a sensation. Their unprecedented precision appealed to biologists and engineers alike. Otto Lilienthal, the aviation pioneer whose first attempts at manned flight Anschütz also captured in snapshots, reputedly took pointers from them for the design of his flying machines. The present appeal of these early images lies especially in the graphic beauty of their chance choreography. F. L.

Ottomar Anschütz,
Otto Lilienthal on Fliegeberg,
August 16, 1894

 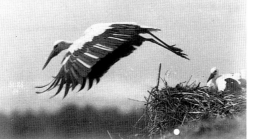 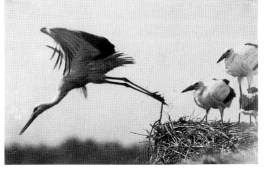

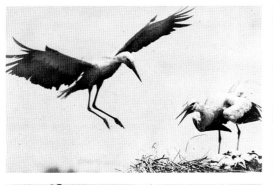 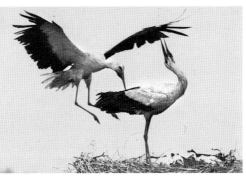 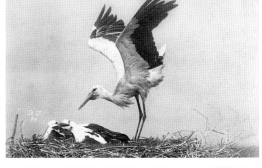

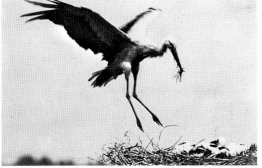 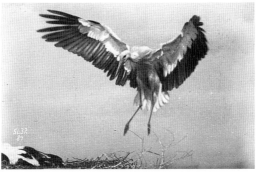 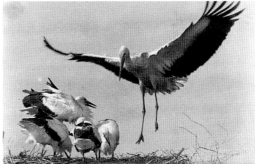

Etienne-Jules Marey

ETIENNE-JULES MAREY

◼ 1830–1904

Etienne-Jules Marey was a physiologist. It was not until 1881 that Eadweard Muybridge, during a visit to Paris, acquainted him with the advantages of photography for his investigations. This inspired Marey to develop new equipment.

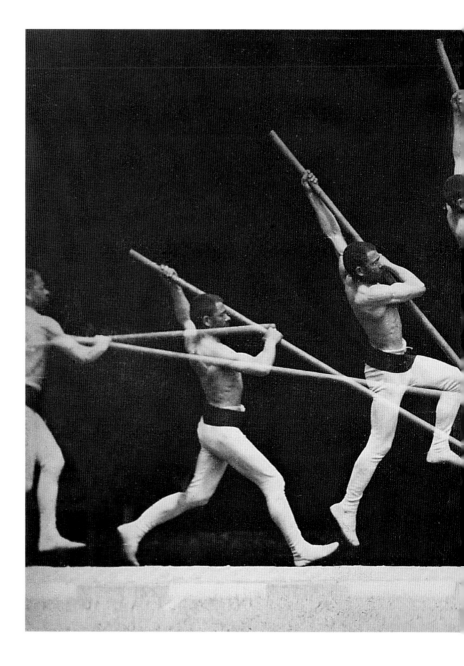

Pole Vault

1890

When Marinetti declared movement an aesthetic maxim in the First Manifesto of Futurism in 1909, Etienne-Jules Marey had been dead for several years. His pioneering works in the field of motion photography were thirty years old. Marey paved the way for the avant-garde, yet he was never interested in exploiting the artistic potential of his results. He viewed himself as a scientist whose investigations were devoted to the modes of movement and muscular functioning of human beings and animals.

Before turning the advantages of photography to this end, he built astonishing apparatus, such as a sphygmograph, which registered the pulse beat on paper blackened with smoke. He fixed birds to recording machines in order to measure the beats of their wings and he was able to prove, around 1870, that for a moment during a gallop, none of a horse's hooves touched the ground—nine years before Eadweard Muybridge provided photographic proof (see p. 102).

With chromophotography, Marey in the early 1880s developed a technique of recording rapid motion sequences in sharp, separate images. Although in principle this was not new, what distin-

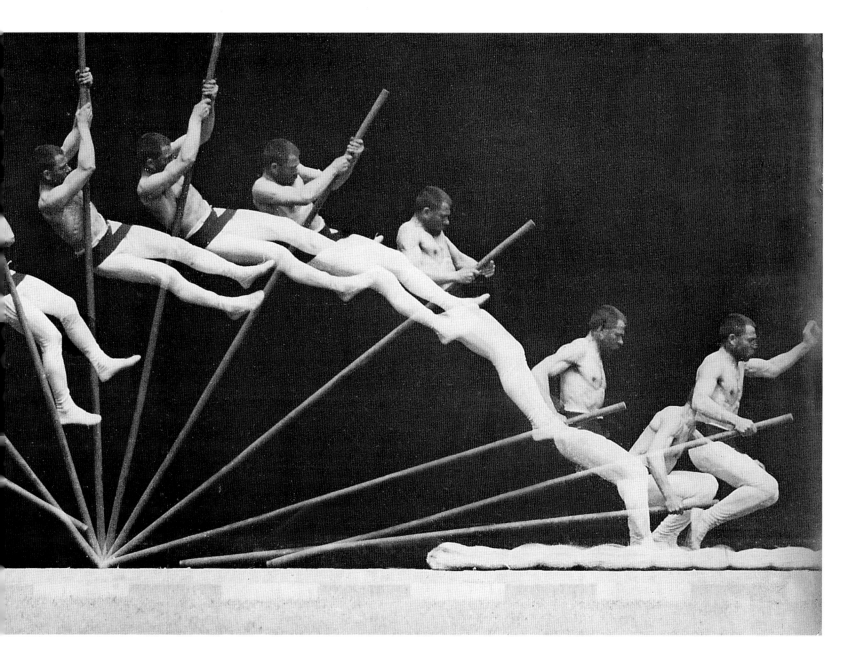

guished Marey's sequences from Muybridge's was that he required only a single camera to make them. Marey's first invention in this field was the "photographic shotgun" of 1882. The same period saw him working on a chromophotographic camera with fixed plate. By means of a rapid succession of exposures, motion sequences were recorded on a single image. Marey did not see the aesthetic appeal of dividing the movements of animals or birds or the motions of the jaw in chewing. And if he tried to discover the secrets of athletic movement, it was merely to convey it to others. Marey was even convinced that a blacksmith's apprentice could learn the perfect hammer blow by looking at a photograph of his master performing one.

However, Marey was aware of the fact that artists and sculptors had profited from his invention. He devoted an entire chapter in his book on chrono-photography to its "Application in the Visual Arts." F.L.

Locomotive after Crashing Through Wall
of Gare Montparnasse, Paris October, 1895

Due to longer tunnels and higher bridges, railroad accidents in the nineteenth century far surpassed those in traditional horse-drawn carriages. Disasters with great numbers of victims led to an association of the railroad not only with technological progress but with delusions of grandeur on the part of its builders. In 1879, the bridge over the Firth of Tay on the east coast of Scotland collapsed during a storm, taking a passenger train with it. Theodor Fontane's poem on this incident became his greatest literary success at that time.

Not only in their infancy but for decades following their invention, locomotives continued to be looked upon as embodiments of demonic powers. When the heroine of Tolstoy's 1877 novel, *Anna Karenina,* decides to put an end to her life, a freight train pulls into the station, symbolizing a projection of her longing for self-destruction. And even as late as 1890, in Emile Zola's novel *La Bête Humaine,* a steam engine plays a key role, when the drunken engineer, struggling with his stoker, instead of stopping his train lets it rush to certain destruction.

To a contemporary viewer, this photograph of a steam engine that has broken through the wall of a station might recall a surrealist montage à la Max Ernst. Every law of nature and reason seems turned on its head, and the logic of anarchy reigns. Nor will the absurd aspect of the picture have been entirely lost on viewers. However, in 1895, people were still receptive to something we prefer to suppress—the demonic side of man-made catastrophes. W. W.

Pierre Petit, *The Eiffel Tower under Construction,* 1888

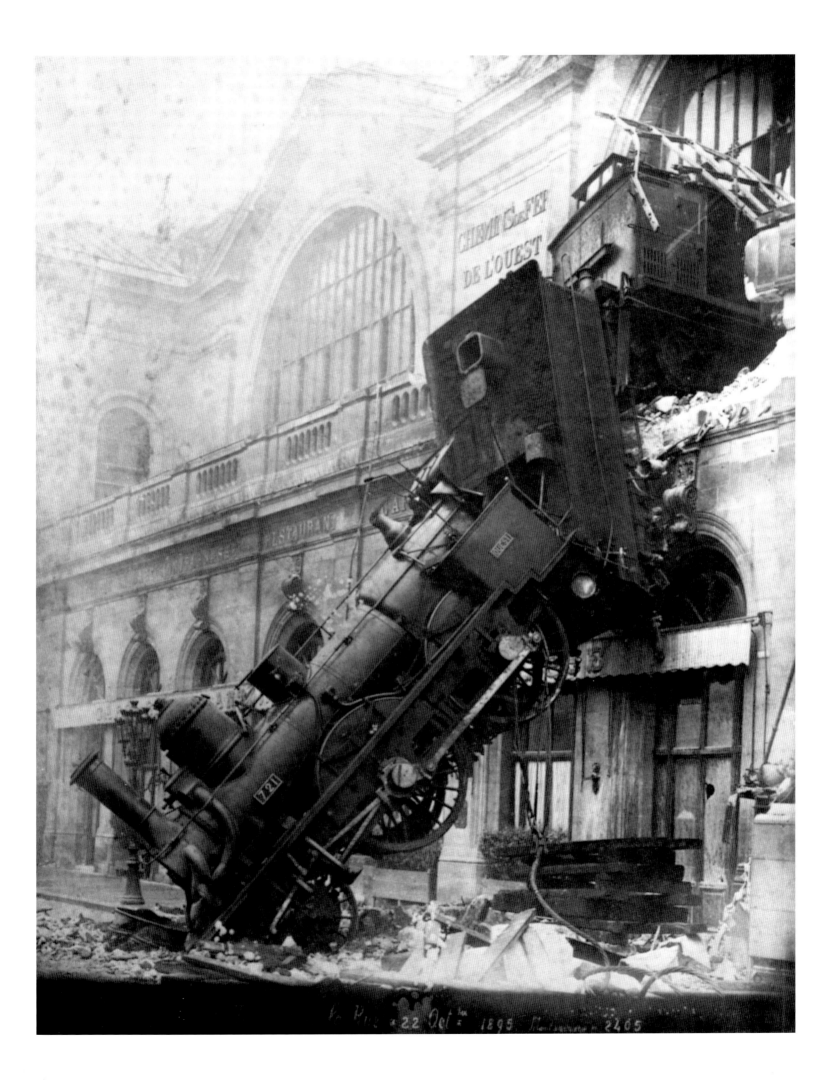

Chemin de Fer de l'Ouest · Restaurant · la Pont 22 Oct 1895 2405

Salomon Auguste Andrée

The "Eagle" in Polar Ice 1897

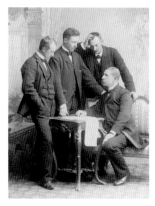

SALOMON AUGUSTE ANDRÉE
● 1854–1897

was an engineer and official in the
Swedish Patent Bureau—pictured
seated on the right. He was also a
technician and inventor. In the
summers of 1882 and 1883 he
participated in expeditions to
Spitzbergen and developed the
idea of crossing the North Pole in
a hot-air balloon. This group portrait
shows the crew of the "Eagle." G.V.E.
Svedenborg (*far left*) did not accom-
pany the expedition.

When the hot-air balloon "Eagle" touched down on the ice of the Arctic Sea on July 14, 1897,
Salomon Auguste Andrée, Nils Strindberg, and Knut Fraenkel had to bury all hopes of reaching the
North Pole. Only three days previously they were Swedish heroes who had started their flight from
the Danish islands northwest of Spitzbergen. Unfavorable weather and equipment problems put a
rapid end to their expedition. With great presence of mind they photographed the deflating balloon,
before setting off to return home on foot. Despite having a sled and even a boat, the three explorers
did not get far, and for decades their fate remained unknown.

It was not until the summer of 1930 that a team of seal hunters and scientists on the *MS Bratvag*
discovered Andrée's last camp on the glacier-covered island of Vitö. Besides the men's skeletons they
found equipment, including diaries and exposed film rolls. Although the celluloid was completely
waterlogged and partially peeled into layers, experts at Stockholm Technical College managed to
restore twenty of the total of one hundred and ninety-two negatives. They amounted to a heart-
rending record of a desperate struggle. They were a metaphor for human hybris as eloquent as
Caspar David Friedrich's painting of a hundred years before—the ship "Hope" crushed between
arctic ice floes—a canvas occasionally known by the ambiguous title of *Vain Hope*. F. L.

Salomon Auguste Andrée, *The "Eagle" Taking Off*, July 11, 1897

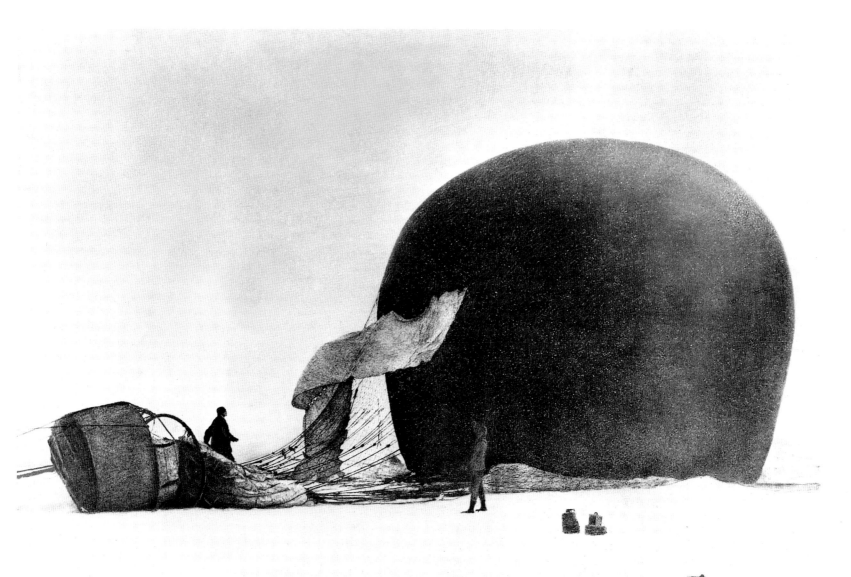

The Henry Brothers

The Firmament, taken from the Paris Observatory 1896

The Henry Brothers, *The Moon, c.* 1885

It was not a coincidence that astronomers coined the term "photography" independently in English and German and first used it in 1839. The camera obscura had been one of the tools of this science for some time. When the photographic process was introduced, it attracted immediate attention. Yet initially the materials used for printing were not sensitive enough and its exposure times took too long to produce useful results.

Astronomers were interested in improving visual records of the heavens. They wanted to establish precise distances between the stars and produce a comprehensive celestial atlas. It was not until about fifty years after the invention of photography that conditions were right for a photographic chart of the firmament. At an international congress in Paris in spring 1887, a suggestion had been made that observatories around the world should supply images on the basis of certain criteria. Advocates of the project included the Henry Brothers, who had long devoted themselves to this idea. However, the chart was never completed, and the project was finally abandoned in 1970.

The surviving astro-photographs are witness to unfulfilled dreams. At the same time, they point to an essential trait of photography—the way it represents objects in juxtaposition, regardless of their actual position or distance, creating a new world whose beauties are capable of awakening the dreamer in all of us. T. S.

PAUL HENRY
1848–1905

PROSPER HENRY
1849–1903

The Henry Brothers were employed as astronomers at the Paris Observatory and, from 1872, were responsible for its stellar charts. In 1884 they began to use photographic methods and they built a special lens for astro-photographic purposes. In addition to cartographic images of the stars, they took sequential photographs of temporary phenomena such as the appearance of comets.

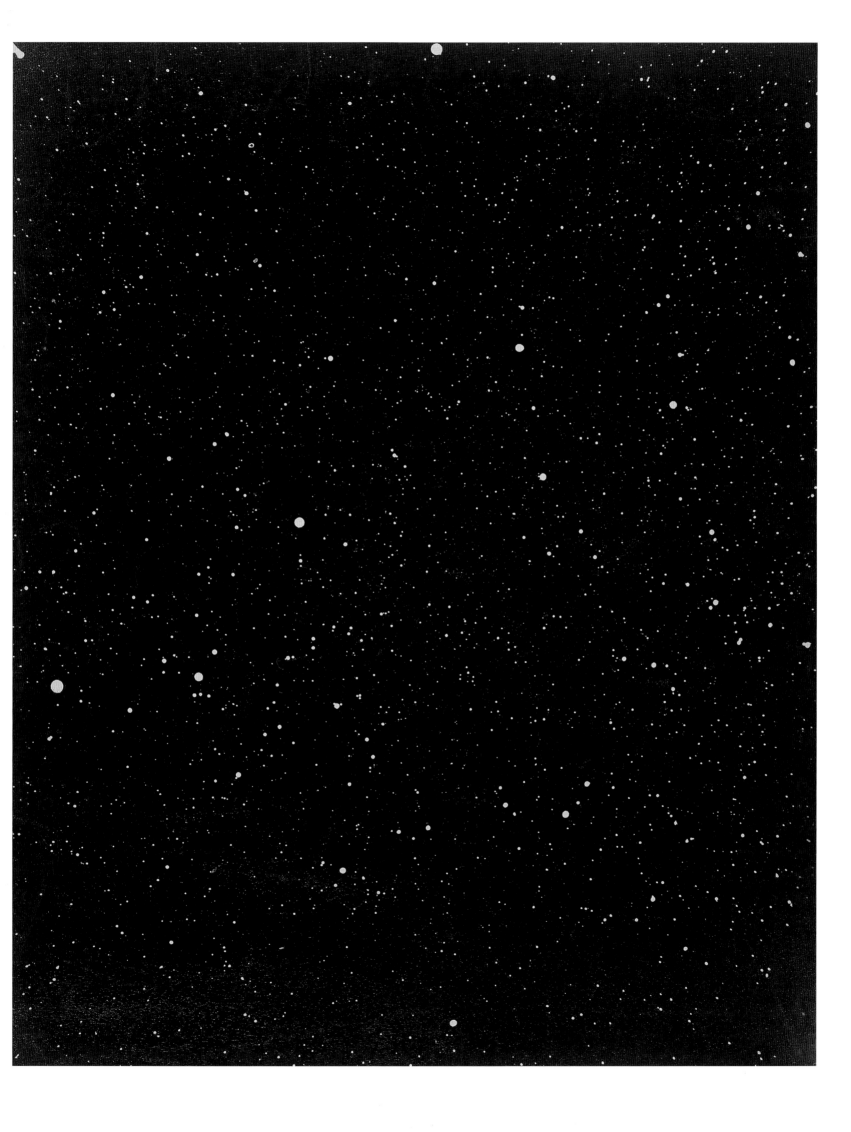

Benjamin Stone

Inner View of Big Ben's Dial 1897

BENJAMIN STONE
1838–1914

was a man of many occupations and interests–politician, social worker, geologist, astronomer, entrepreneur in the glass and paper industries, as well as author of several books. Due to his many journeys throughout the world, however, he was half-hearted about most of these activities. Only in photography, his hobby, did he produce outstanding work. Stone is said to have taken thirty thousand pictures. He devoted series to portrayals of his fellow parliamentarians, but he also took photographs of artisans and vagabonds. A selection of his photographs appeared in 1906, in the two-volume work *Sir Benjamin Stone's Pictures: Records of National Life and History.*

"When a man is killing time, he is wasting his life," Benjamin Stone concluded a lecture on "How We Can Best Employ our Lives," delivered to the Erdington Literary Association on October 8, 1881. Such maxims can probably be best attributed to the Victorian values of strictness and discipline rather than being a reflection of any aesthetic program. Still, when he set up his camera in Big Ben in order to photograph a gentleman standing next to the glass face of the huge clock, Stone must have been concerned with more than a record of the elaborate mechanism or reminding people of the transitoriness of human effort.

Stone's image is a visual metaphor for the close link between time and photography. In no other medium does the phenomenon of time find such consummate expression. This becomes clearly evident in the effects of extremely long and extremely short exposures, which reveal aspects of the world invisible to the human eye. And it becomes evident when photography captures the present moment. Actually, a photograph can do no more than record the past—as soon as the shutter is snapped, the photographic moment is over. Photography, then, represents an attempt to bring time forever to a standstill, and thus to lend the moment eternal life.

Based on just this insight, Stone, in the summer of 1897, encouraged the foundation of the National Photographic Record Association, devoted to recording customs and festivities throughout the country that might soon fall victim to industrialization. Over the following ten years the Association was able to present 4, 162 prints to the British Museum, and a number of local historical museums and libraries also profited from its work.

Benjamin Stone, *Sippers and Topers at Bidford Mop, c.* 1900

One aspect of Stone's contribution could be found in his weird stage productions using strange, fantastic figures depicted as if they were messengers from a dream world; another aspect could be found in his portraits of workers and farmers, who must have seemed no less peculiar to the wealthy gentleman. F. L.

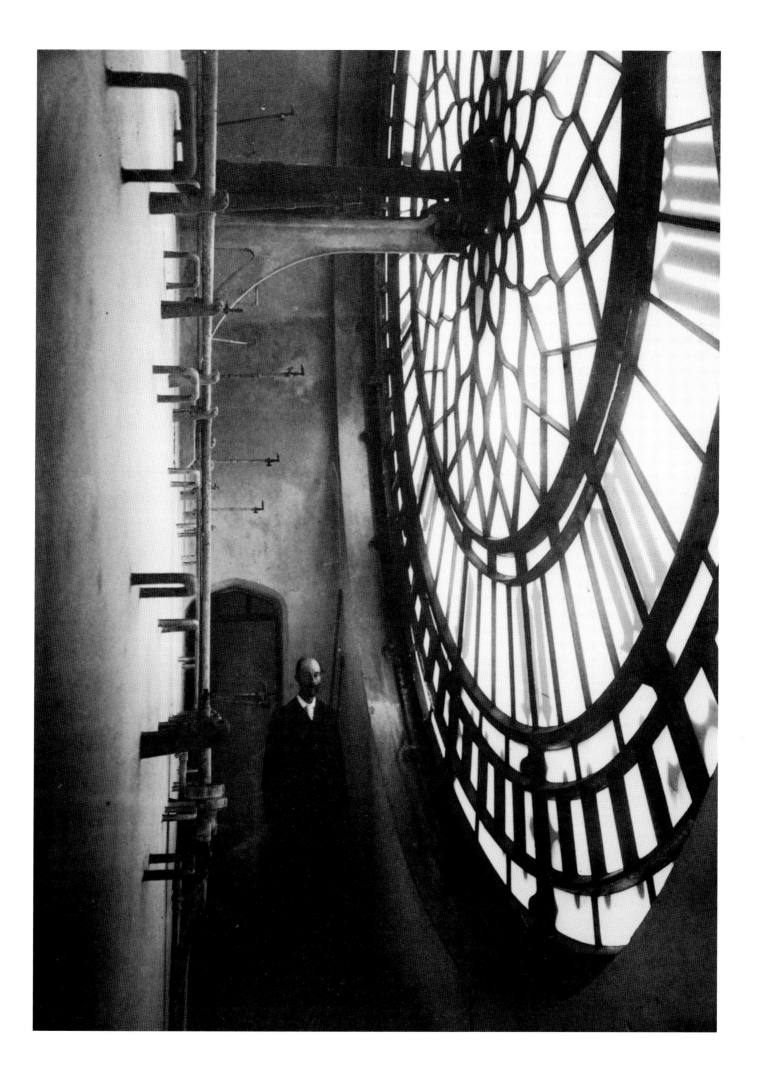

Frederick H. Evans

Portrait of Aubrey Beardsley 1893

FREDERICK H. EVANS

1853–1943

before devoting himself entirely to
photography in 1898, was a respected
London bookseller whose clients
included writers and artists like George
Bernard Shaw and Aubrey Beardsley.
Through two successful exhibitions in
1897 and 1900 he made contact with
Alfred Stieglitz, who opened the pages
of his journal *Camera Work* to Evans'
prints and essays. In the aftermath of
heated debate, however, Evans broke
with the Pictorialist group and concen-
trated entirely on repro photographs
of drawings by Blake, Holbein, and
Beardsley, which he privately published.

Frederick H. Evans was an outspoken advocate of pure photography who, despite his close connec-
tions with the Pictorialists, abhorred the picturesque effects of their de luxe prints. Yet this by no
means made him a staid documentarist—quite the contrary. "Try for a record of emotion rather than
a piece of topography," Evans advised his readers in one of his many essays—in fact, in an introduc-
tion to architectural photography, of all things.

In 1890 he had begun to photograph Gothic cathedrals in England and France. They were
almost exclusively interiors that were always devoid of life, often cropped severely, but with a sense
of the majesty to be found in these structures. Evans could spend weeks in these churches, studying
the effects of space and illumination. His masterpiece, *A Sea of Steps*, was taken in Wells Cathedral in
England. Seemingly infused with life, the steps are transformed into dark surging waves above
which an archway stands in brilliant light like a place of salvation and a promise of resurrection.

No less impressive is Evans's portrait of the artist and his close friend Aubrey Beardsley. For
hours and hours, the story goes, Evans walked around the young man in search of the right picture.
Not until Beardsley, bored and weary of waiting, rested his chin on his hands did Evans get the
picture he wanted. The long, Gothic-like fingers and narrow face revealed the architecture of facial
anatomy. F. L.

Frederick H. Evans,
A Sea of Steps, 1898

Wilhelm von Gloeden

Faun *c. 1900*

There have been many artists who have provoked their contemporaries by treating exalted subjects from mythology and religion or great epochs in art in a way that is anything but sublime. And every time, they were accused of debasing the theme. These artists and their followers have argued that their naturalistic approach has at last lent credence to the images. In the history of painting, Caravaggio is the classic example of such an artist.

The history of photography has its protagonists as well, and Wilhelm von Gloeden was one of them. His photographs, taken in Sicily, are often censured as homo-erotic soft pornography, and seemingly many of them were indeed for homosexual clients. This verdict, however, does not do justice to his artistic vision. Gloeden believed he had found in Sicily a kind of ecological niche, where a piece of Greco-Roman antiquity had managed to survive. When he posed local youths in front of the ancient ruins of Taormina or draped them in period costumes and accessories, he believed he was invoking the beauty, gods, heroes, and fabled beings of the Ancient World.

If we are sometimes disturbed by the vulgarity of his models, this, to Von Gloeden, may well have been further proof of the vitality and authenticity of his vision. His camera was his time machine.

W. W.

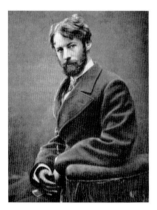

WILHELM VON GLOEDEN
1856–1931

studied art history in Rostock, Germany, and painting in Weimar. In 1878 he moved to Taormina, Sicily, and participated in several exhibitions of art photography during the *fin de siècle*. After the loss of his inheritance, he became a professional photographer in 1895. Von Gloeden's villa was a gathering place of high society. His visitors included Oscar Wilde, Eleonora Duse, Anatole France, the King of England, the Crown Prince of Prussia, and industrialists and bankers such as Krupp, Vanderbilt, and Rothschild. Von Gloeden is buried in Taormina.

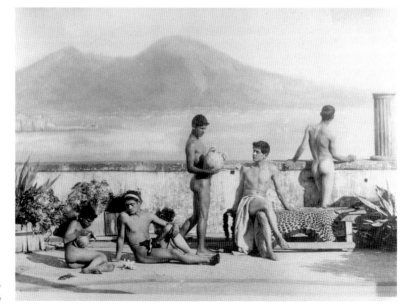

Wilhelm von Gloeden,
Naples, c. 1895

118

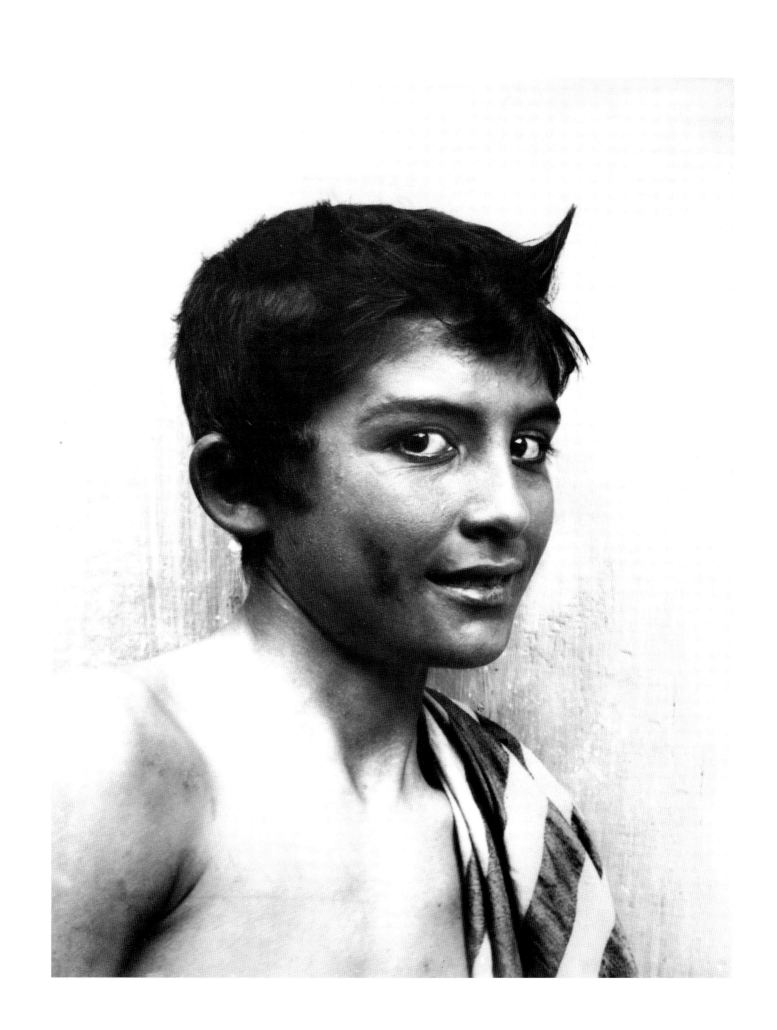

Gertrude Käsebier

Blessed Art Thou Among Women 1899

GERTRUDE KÄSEBIER
1852–1934

was among the founding members
of the Photo Secession, an American
group of Pictorialists around Alfred
Stieglitz. While other photographers
gradually abandoned the painterly
style and elaborate print processes
and turned to "pure" photography,
Käsebier remained faithful to the ro-
mantic approach. She continued to
run her New York studio until 1927.

Gertrude Käsebier did not begin to take photographs until she was almost forty. She had just completed a course in art and her children were on the verge of adulthood. Both circumstances were to shape her work: painting her Pictorialist style, and the role of mother as her choice of subject matter. After practicing with the new medium on members of her family, she opened a studio for portrait photography in Paris in 1894, followed by another in New York in 1897. The mother-child relationship continued to be a central motif in Käsebier's non-commercial work throughout her career.

Her double portrait of Agnes Rand Lee, an American writer and author of children's books, and her daughter Peggy is a case in point. Its title, *Blessed Art Thou Among Women*, derives from the painting in the background, an Annunciation scene by the English artist Selwyn Image. The angelic look of the mother is underscored by her flowing reform dress. She escorts the little girl through a doorway as if into the wide world. Although the child hesitates on the threshold as if afraid to take the decisive step, her gaze and pose convey self-confidence. Because Peggy died shortly after the picture was taken, Käsebier initially decided not to release it. It became her most famous work, when Alfred Stieglitz published it in the first issue of his pioneering journal *Camera Work* in 1903, along with other photographs by Käsebier, which similarly relied on Christian iconography, such as *The Manger.*

The death of Peggy was not the last stroke of fate to befall the Lee family. Their other daughter went deaf, causing her pious father, who attributed it to a curse, to leave his wife. When Käsebier photographed Agnes Rand Lee again in 1904, she captured her mood of mourning with almost Symbolist compellingness. F. L.

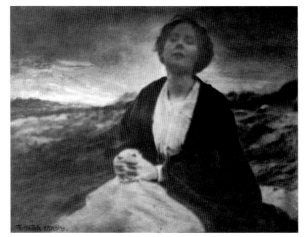

Gertrude Käsebier,
*The Heritage of Motherhood
(Portrait of Agnes Rand Lee)*, 1904

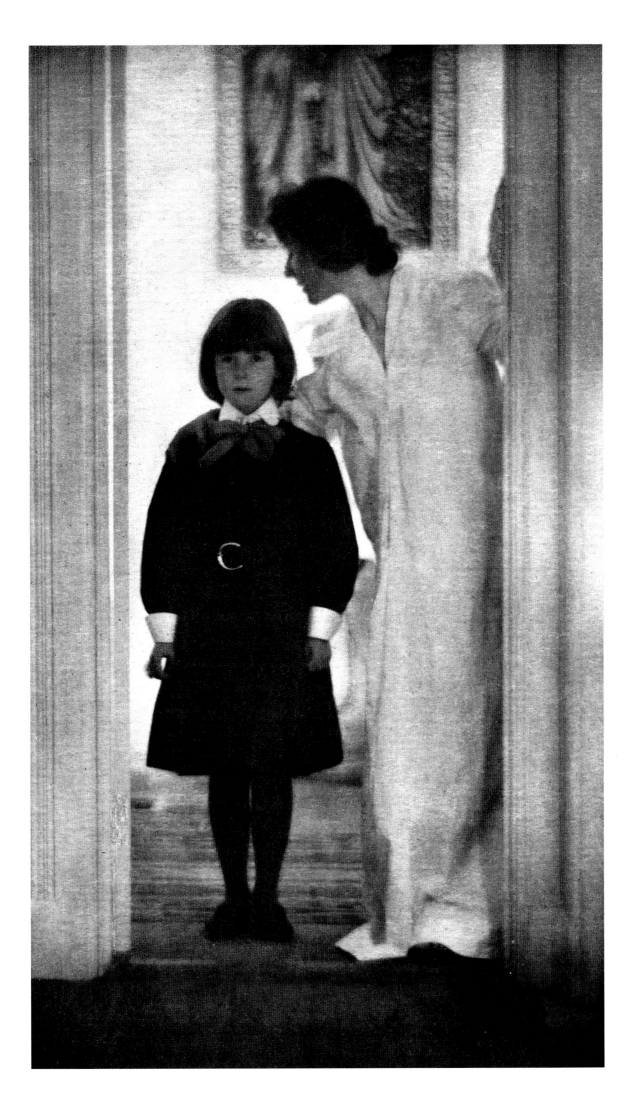

Heinrich Kühn

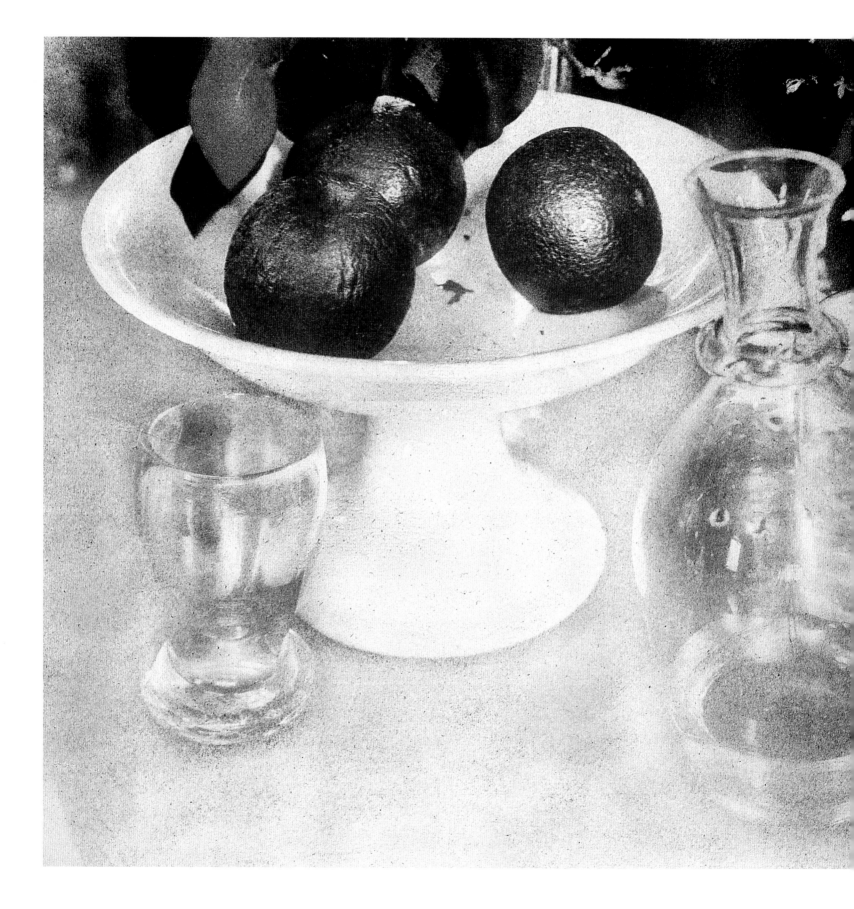

Still Life *c.* 1900

The Pictorialist style, in existence towards the end of the nine-teenth century, was long looked down upon as an aesthetic misunderstanding. Its practitioners were not interested in the quintessential traits of the photographic medium, its sharp con-tours, and often unintended richness of detail. They sought painterly effects. Not only their themes were derived from dark Symbolism or the flickering light of Impressionism, but their manner of depiction as well. Visible brushwork on canvas, for instance, became coarse-grained or blurred photographs. Even before releasing the shutter, Pictorialist photographers would sometimes deliberately not focus properly or drape a veil over the lens. Prints were processed by elaborate manual methods such as gum printing or bromide oil printing, in which so many layers of ink were applied that it seemed to protrude from the surface of the rough-grained paper. Every image—and this was a key aspect of the approach—became a unique, one-off image.

For Heinrich Kühn, lack of focus was not a stylistic end in itself. He understood blurring as the way to convey the natural visual experience of a moving atmospheric moment. "You must be able to feel the warmth of the light emanating from a picture," he described his artistic approach. He was most successful in put-ting this into practice in his still lifes with glass objects. Here, light has much more than a mere modeling effect. The glittering reflections and illuminated surfaces seem almost to take on a life of their own, to become objects in their own right. Perhaps more than any other photographer, Kühn deserves the title of *Licht-bildner,* the now outmoded German term for photographer, which literally translates "imagemaker in light." F. L.

HEINRICH KÜHN
1866–1944

Heinrich Kühn (1866–1944) studied medicine and in 1887 experimented with microphotography at the Institute of Pathological Anatomy in Innsbruck, Austria before deciding to devote him-self entirely to photography. A member of the Vienna Camera Club and the highly regarded Linked Ring Associa-tion, he promoted art photography in many of his essays. Concentrating on family themes and images of the Tirolean environment, he remained true to Pictorialism well into the 1930s, although his colleagues—including Alfred Stieglitz and Edward Steichen—had long since turned to a lucid, pure photographic style.

Alfred Stieglitz

Spring Showers 1900

ALFRED STIEGLITZ
1864–1946

came from New Jersey to New York
in 1871, trained in photography and
photo-chemistry in Berlin, and began
to participate in exhibitions in the latter
half of the 1880s. After several trips to
Europe, he returned to the U. S. in
1890. As editor of photographic and
art journals and founder of a gallery
in New York, he introduced the most
significant artistic photographers of
the day. Stieglitz maintained contact
with the leading representatives of
Pictorialism and later of sharp-focus
Sachlichkeit around the world. He
played a central role on the American
scene, which he influenced for a
long time.

In the 1890s an amateur movement emerged that criticized the lack of artistic qualities in the highly detailed images and stereotyped, arranged productions of professional photography. It advocated the use of antiquated printing processes and its representatives retouched negatives by adding color tones and used special handmade papers for their prints. The movement's representatives described themselves as artists and they believed that photographers should have a similar mastery of their craft. Known as Pictorialists, their favorite themes included fields of wildflowers, cozy corners, people on country outings, and still lifes. They largely ignored subjects like labor, industry, and architecture.

One of their key devices was the lack of focus, which lay like a veil over the photograph. Similar effects could be achieved by photographing at twilight or night, in rain or fog. When Alfred Stieglitz walked the streets of New York with his camera, it was not with an eye to recording the prevailing hustle and bustle or the loneliness of the individual in the crowd. He wanted to photograph horse-drawn carriages in a blizzard, light reflections on rain puddles, or parks blanketed in snow. In scenes like these he spirited the everyday world into an idealized state of evocative lights and halftones, and detected moments of surpassing beauty in the mundane urban environment. T. S.

Alfred Stieglitz,
Sunlight and Shadows
1889

124

Eugène Atget

JEAN EUGÈNE AUGUSTE ATGET

1857–1927

came to Paris in 1878 and worked as an itinerant actor for several years. He took up the camera in the mid 1880s, initially making studies of various motifs for artists. By the end of the century he had expanded his repertoire to include urban and architectural photographs and gained public departments as clients. Atget is not only considered the greatest documentarist of historical Paris. His fragmentary approach and views of reflections in the glass windows anticipated the avantgarde and Surrealist photography of the 1920s.

Café "À l'Homme Armé," 25 rue des Blancs-Manteaux (4e. arr.) 1900

In the latter half of the nineteenth century, industrialization and mass migration from the countryside radically changed the face of large cities. Venerable buildings had to make way for residential structures and factories, and entire districts were destroyed to create new transportation networks. At virtually every site, there seems to have been a photographer who attempted to make a visual record of the surroundings that would soon no longer exist.

In Paris, Eugène Atget was a chronicler of the present moment as it slipped into the past. Usually in the early morning, when few people were in the streets, he would wander through the city, photographing one house after another in a certain district. He not only recorded individual facades, but explored courtyards and stairwells, and also observed people plying street trades that were threatened with extinction. Display windows and building entrances also attracted his attention, especially when they were adorned with signs. There were few street names at this time and fewer house numbers, and so signs served as points of orientation for people who were unfamiliar with the area.

The "armed man" in the photograph appears to be standing guard over the past in the rooms that are behind him. At the same time, a waiter, standing in the restaurant and looking out through the glazed door, seems to gaze into the uncertain future of a new century, at the turn of which this picture was taken. T. S.

Eugène Atget, *Bitumiers*, 1899–1900

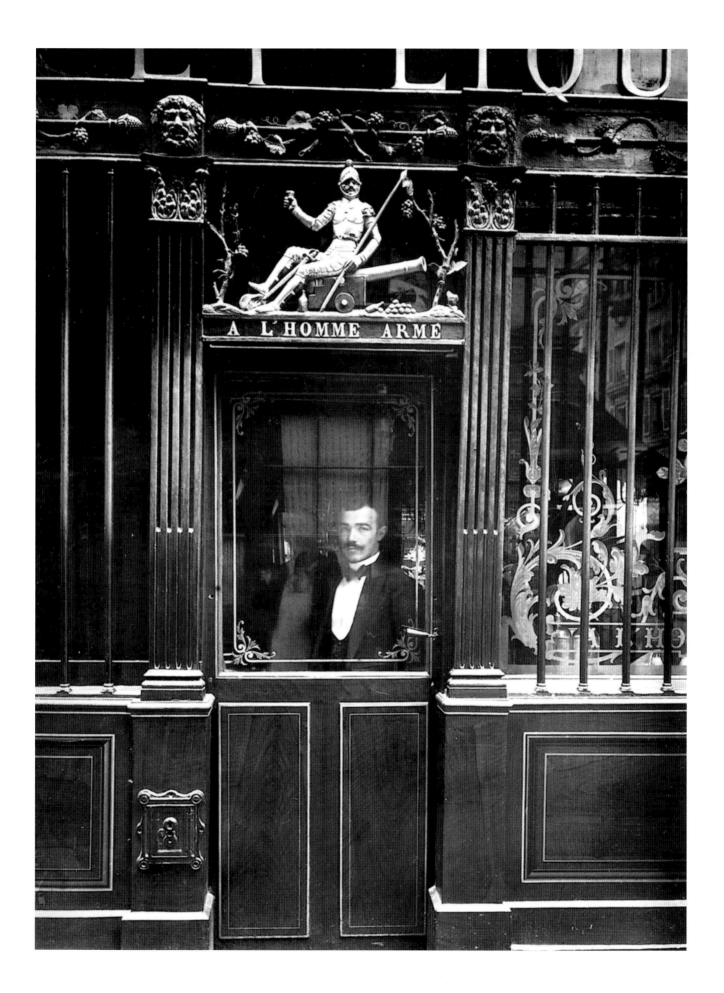

Photographic Credits